The Baroque Painters of Italy

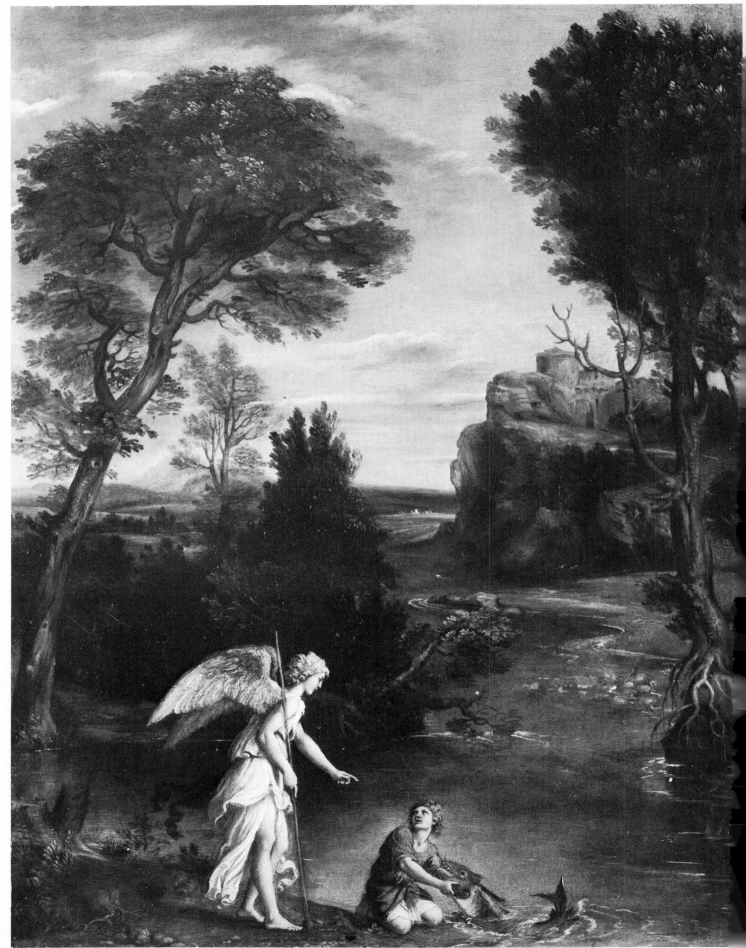

The Baroque Painters of Italy

Charles McCorquodale

Phaidon · Oxford

Phaidon Press Limited, Littlegate House,
St Ebbe's Street, Oxford

First published 1979
Published in the United States of America
by E.P. Dutton, New York
© 1979 Phaidon Press Limited
Text © by Charles McCorquodale
All rights reserved

ISBN 0 7148 1967 0
Library of Congress Catalog Card Number: 78-20577

Printed in Great Britain by Waterlow (Dunstable) Ltd

Frontispiece: Domenico Zampieri, called Il Domen-
ichino (1581–1641): *Landscape with Tobias Laying hold
of the Fish.* Copper, 45.1 × 33.9 cm. (17¾ × 13⅜ in.)
London, National Gallery

List of Plates

Bibliography

Although there are some excellent general studies of Italian Baroque painting in English, the great majority of monographs on particular painters are in Italian, as are many of the scholarly articles dealing with lesser-known figures. For this reason, the following outline bibliography contains the titles of studies in Italian which the general reader may care to consult for their plates alone. The bibliography is presented chronologically.

1642 Giovanni Baglione, *Le Vite de' Pittori, Scultori, ed Architetti*. Facsimile edition, Rome, 1935.

1672 Giovanni Pietro Bellori, *Le Vite de' pittori, scultori ed architetti moderni*.

1681–1728 Filippo Baldinucci, *Notizie de' professori del disegno da Cimabue in qua*. Facsimile of Ranalli edition, Florence, 1846–8, Florence 1974, 7 vols.

1678 Carlo Cesare Malvasia, *Felsina Pittrice, Vite de' pittori bolognesi*.

1772 Giovanni Battista Passeri, *Vite de' pittori, scultori ed architetti che hanno lavorato in Roma, morti dal 1641 fino al 1673*.

1795 Luigi Lanzi, *Storia pittorica della Italia*, 6 vols. Later English editions.

1924 Herman Voss, *Die Malerei des Barock in Rom*.

1929 Benedetto Croce, *Storia dell'eta barocca in Italia*.

1932 Emile Male, *L'Art religieux apres le Concile de Trente*.

1947 Denis Mahon, *Studies in Seicento Art and Theory*.

1950 Vincenzo Golzio, *Il Seicento e il Settecento*.

1955 Denis Mahon and Denys Sutton, *Artists in 17th Century Rome*, exhibition catalogue, Wildenstein (London).

1963 Francis Haskell, *Patrons and Painters. A Study in the Relation between Italian Art and Society in the Age of the Baroque*.

1963 Ellis K. Waterhouse, *Italian Baroque Painting*.

1965 Rudolph Wittkower, *Art and Architecture in Italy 1600–1750*.

1970 Jonathan Brown and Robert Enggass, *Sources and Documents in the History of Art: Italy and Spain 1600–1750*.

1973 Clovis Whitfield, *England and the Seicento*, exhibition catalogue, Agnew's (London).

1973 Matteo Marangoni, *Arte Barocca*.

1973 *Il Seicento Lombardo*, exhibition catalogue (paintings volume), Milan.

1976 Ellis Waterhouse, *Roman Baroque Painting*.

1976 Walter Friedlaender, *Mannerism and Anti-Mannerism in Italian Painting*.

1979 Charles McCorquodale, *Painting in Florence 1600–1700*, exhibition catalogue, Royal Academy, London and Fitzwilliam Museum, Cambridge.

The above of necessity lists only general studies, and the reader is advised to consult the bibliographies of the more recent publications for individual monographs.

The Baroque Painters of Italy

At no time since the Baroque era in Italy has the European social and political climate been so different from ours. The dynamism, unswerving self-confidence and intense religiosity of that period are diametrically opposed to the twentieth century's uncertainty and secularism—a factor which complicates our appreciation of the Baroque style at its most extreme. The Baroque represents Catholic supremacy at its height—after the shattering doubts resulting from the Protestant Reformation and the Sack of Rome, but before the scepticism of the Age of Reason. It is between these polarities that Baroque art lies, growing out of the Mannerism of the sixteenth century and merging, perhaps less perceptibly, into the Rococo of the eighteenth.

Strictly speaking, the Baroque is the style of the seventeenth century, which reached its fullest expression in the painting of artists such as Lanfranco, Cortona and Baciccio, the sculpture of Bernini and the architecture of Borromini. But in the same way that general terms like 'Renaissance', 'Mannerist' or 'Impressionist' cover the styles of many different artists who, although they may share certain common characteristics, are fundamentally different, 'Baroque' is now used with considerable freedom. A glance through the plates in this book shows countless different personal styles: how utterly different is Cortona's Barberini Ceiling (Plate 31), for example, from Carlo Dolci's *David* (Plate 54), or Domenichino's *Death of St Cecilia* (Plate 23) from Castello's *St Genevieve* (Plate 60)! Yet despite this, each has certain features which link it to clearly definable seventeenth-century ideals. The exact origin of the word *baroque* may never be discovered, but, like many such terms, it appears to have been initially derogatory, and in the most general application its suggestions of exuberance or extravagance are often relevant in the seventeenth century. This is especially so in Rome, where the style first reached its most coherent form, by which the achievements of the other Italian centres—Florence, Naples, Venice, Genoa or Milan—must be gauged.

The centralization of art in seventeenth-century Italy inevitably occurred in Rome. After the Sack of Rome by Imperial troops in 1527, and the sudden dispersal of many painters who had been concentrated there, the principal art centres were Florence, Venice, and, to a lesser degree, Parma. The Sack brought sharply to an end the High Renaissance, a period of about twenty years during which Raphael, Michelangelo and others had perfected the ideals of the Quattrocento. Many of the painters who fled from Rome were to join in the creation of the Mannerist style with its opposition to the classical balance and optimism of the High Renaissance; among the most important were Francesco Parmigianino, Agnolo Bronzino, Francesco Salviati and Giorgio Vasari. Michelangelo, from whom many of the constituents of Mannerism derived, was to remain the principal constant in Roman art until his death in 1564. Vasari believed that there could be little development from Michelangelo's style, and for certain artists this was undeniably true. *The Martyrdom of St Lawrence*, painted by the aged Bronzino in 1569, which reveals the most extreme effects of Michelangelo's approach to the nude, is one of the most typical examples of later

7

Mannerism. Little distinction is made between the individual parts of the composition and, devoid of emotion, the tragic death of the saint is reduced to a formula based on the mechanical interchange of human parts. This was also typical of many other such decorations which spread across the walls of Italian palaces and churches during these years, rendering totally unintelligible both simple narratives and the highly complex 'programmes' of Mannerist painters like Vasari.

But by the time Bronzino completed this fresco, its abstruse style was already coming under fire. The Council of Trent, opened in 1545, had ended in 1563. Its aims and achievements had been much-needed ecclesiastical reform and a counter-attack on the Protestant Reformation. It was out of this attack, with its attendant programmes for popularizing and de-intellectualizing Catholicism, that the climate in which the Baroque was conceived came about. Bearing in mind, however, that the most complete manifestations of the Baroque did not appear until well over half a century later, it will be seen that the terms 'Counter-Reformation' and 'Baroque' are far from referring to the same period. The Catholic Church's attack on both incipient and established Protestantism was hardly hesitant. The foundation of the Jesuit Order by Ignatius Loyola in 1534 was tantamount to the establishment of a Catholic army. Its weapons were not, however, those of the *condottieri*. The Jesuits set out to win the mind not the body, by means of inspired but sane preaching and rigorous programmes of education both for clergy and laity; in such a system heresy would have no place.

Despite opposition, the Jesuits quickly spread throughout Italy and further afield. In Bologna, soon to be a centre of major artistic reforms, Cardinal Gabriele Paleotti (1522-97) set out to combat the lethargy that he rightly saw as the fuel on which Protestant fire could

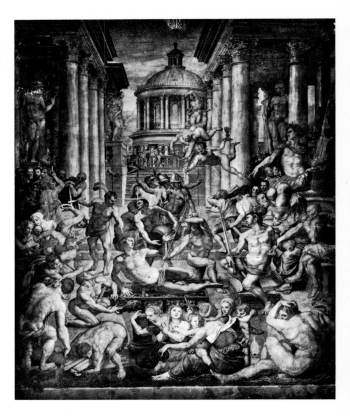

1. Agnolo Bronzino (1503–72): *The Martyrdom of St Lawrence*. Signed. 1569. Fresco. Florence, S. Lorenzo

feed. Modelling his programme on St Philip Neri's *Oratorio Romano*—another body founded to reunite Church and people—Paleotti's seminary educated future priests in the liturgy, catechism, grammar and rhetoric.

With the help of the intellectual Ulisse Aldrovandi, Paleotti wrote a treatise on painting which encapsulates many of the Counter-Reformation's theories on the use of the visual arts as propaganda in the fight against heresy. Mannerist art was an aristocratic art appealing to a small educated minority. When painters had to provide explanatory texts for certain of their pictures there could be little hope of their art reaching a wide public. In any case, this was never the Mannerist painter's aspiration, since his preferred audience would admire not narrative sim-

8

plicity but rather elevated erudition and deliberate complexity. This could not fail to alienate the ordinary man, who, when confronted with a painting such as Bronzino's *St Lawrence*, must have been confused and dismayed by the artist's apparent lack of sympathy with the story. In his *Discourse concerning sacred and profane imagery*, published in a provisional form in 1582, Paleotti advocated a more universal application of art. He saw the role of the Christian painter (*pittore Cristiano*) as similar to that of the preacher: he must instruct, uplift and move the spectator, *however simple*, bringing him into a direct human relationship with the stories represented. He must conjure up the wealth of God's creation for the ordinary man, showing him not the rarefied features of court life, but the 'men, animals, plants, rivers, palaces, churches and all the riches to be seen in this great worldly creation'. Precisely this expansion of the thematic horizon characterizes seventeenth-century painting, with its new interest in still-life, landscape, genre and other categories to which the preceding century in Italy had paid scant attention.

Apart from Paleotti's reforms, together with those of others such as Carlo Borromeo in Milan and Philip Neri in Rome, many of the other features which helped to form the Baroque age are found in the sixteenth century. Ignatius Loyola's *Spiritual Exercises* became a guiding force not only with the Jesuits but for many artists, including Bernini. The reader is carefully led to use each of his five senses to imagine for himself the scenes of the Passion, the torments of Hell, or the bliss of Heaven, together with all of the sensations attendant on death and subsequent decay. This emphasis on the strictly physical—paralleled by St Philip Neri's use of Palestrina's music to heighten religious experience—was to become one of the salient features of the Baroque. The tangibility of Caravaggio's figures, the prox-imity of saints to everyday experience even in cloud-swept ecstasies, the rendering credible of visionary experiences—these were all direct products of the changed attitude to religion. Loyola's exhortation not only to imagine these experiences but to attempt their partial re-enactment through the senses cannot have seemed strange to a century in which death was an ever-present reality (Plate 49) and physical transport through ecstasy not uncommon. The ecstatic mysticism primarily associated in the sixteenth century with two Spanish saints, St Teresa of Avila and John of the Cross, also had Italian exponents in the Florentines St Catherine de' Ricci (1522-90) and St Mary Magdalene dei Pazzi (1566-1607); the particular conception of ecstasy which these saints propagated came to be applied even to much earlier saints (Plate 29). St Teresa was able to describe her visions with scientific clarity, and St Catherine de' Ricci experienced hers regularly each Thursday at noon. The fact that such profound inner experiences came to be regarded as a norm to be illustrated as physical events seen in close proximity to the beholder epitomizes the Baroque's ability to envisage everything in human terms.

If the bringing of ultramundane experiences within the comprehension of almost anybody is characteristic of the Baroque, equally so is the creation of a larger public for art both past and present. This is characterized by the emergence at the end of the sixteenth century of guide-books, not to sacred sites or relics, but to art treasures. Bocchi's *Beauties of Florence* of 1591 is the first perfect example of its kind, and others include Bellori's *Notes on Museums* of 1664 and Filippo Titi's 1674 guide to Rome, which was already reprinted in 1686. By the first years of the seventeenth century, professional guides or *ciceroni* are recorded in Rome. Unlike the treatises on painting of the sixteenth century, the Baroque approach was generally less theoretical and

more concerned with facts and with establishing the validity of certain constants such as classicism. Not only is the development of the guide-book symptomatic of a greater artistic self-confidence (the assurance to list paintings which by widespread consent are important), but it also implies that the frontiers of art's appeal were advancing. In 1602, the Florentine Academy of Fine Art was asked to supervise the imposition of a law forbidding the export of works of art by famous masters of *the past* including Michelangelo, Raphael, Leonardo, Titian, Bronzino and Correggio. This coincided almost exactly with the creation in Rome of the Farnese Gallery by Annibale Carracci (Plates 8 and 9)—a triumphant assertion of the rights of several of these painters to be regarded as the unsurpassable models for any future artist.

Much of this activity, it will be noticed, took place outside Rome. Suddenly, however, in the mid-1590s, one of those dramatic shifts of emphasis so dear to the social historian of art took place: Rome became the centre of an unforeseeably concentrated artistic revival. This was heralded by Caravaggio's arrival in the first half of the 1590s and by that of Annibale Carracci in 1595, both of them destined to be the twin stars of the early Baroque. This was during the papacy of Clement VIII, which ended in 1605 and was followed by that of the Borghese pope, Paul V. The reigns of eleven popes neatly span the seventeenth century, ending in 1700 with the death of Innocent XII, and at no time since Julius II and Leo X were the papal and artistic roles so closely interwoven. At the opening of the century, Rome's population numbered 100,000—less than that of Venice, Milan or Naples—but by 1699 there were 135,000 inhabitants; by then the city had begun to decline drastically as a creative centre and was entering its new role of glorious museum. During the seventeenth century, however,

Rome established what has been described as 'the paradox of a spiritual monarchy', notably during the reigns of Urban VIII (1623-44), Innocent X (1644-55) and Alexander VII (1655-67). Urban VIII's papacy set the tone of unprecedented grandeur and extravagance which distinguished Rome from all other cities during the seventeenth century, and set the seal on the careers of Bernini and Pietro da Cortona among many others. With remarkable rapidity, Rome assumed a magnetic position of influence and dominance after the turn of the century, attracting artists from all over Europe.

The prevailing mood in Rome was of the 'Church Triumphant'—the natural successor to the 'Church Militant' of the preceding century. A sense of excitement undoubtedly present at the birth of the new style in the hands of Caravaggio and Annibale Carracci was partly dependent on and partly heightened by the optimistic atmosphere of the Church, whose resurgence after the success of the Counter-Reformation was reflected in its interest in its own earliest beginnings (Plates 19 and 23) and the creation of many new saints. In 1610, Pope Paul V canonized Charles Borromeo (Plate 45), and this was followed in 1622 by the canonization of Saints Teresa, Ignatius Loyola, Francis Xavier and Philip Neri, and in 1629 of Andrea Corsini of Florence. This resulted not only in many new churches and altars throughout Italy dedicated to these saints (whose contemporaneity was in itself an inspiration) but also in the creation of a whole new iconography. 'Rome', says Emile Mâle in his study of art after the Council of Trent, 'is the city of saints, and the art of the seventeenth century celebrated them with as much fervour as France did in the thirteenth.' The proliferation of sacred art during the Baroque era is the direct result of this fervour.

At its centre remained the papacy, around

10

which all the arts and their patronage revolved. Sixtus V remarked that 'Poor princes, and above all, poor popes, come to be despised even by children, particularly in this age when one can do anything with money.' This remained the *credo* of the Baroque papacy, and the result was the embellishment which left Rome as we see it, first and foremost a Baroque city. Religious orders vied with each other, with the papacy, and, more rarely, with secular patrons, in the lavish display of their wealth in art. Churches such as the Gesù, formerly plain to the point of severity, were loaded with costly and elaborate decoration (Plate 57) by rich patrons, sometimes even against the clerics' will, and, following the example of the Barberini (Plate 31), all the major families had huge allegorical frescoes painted all over the ceilings of their palaces (Plate 58). Individually distinguished patrons such as Cardinal Scipione Borghese or Vincenzo Giustiniani paralleled the great family collections of the Barberini or the Medici in a modest but often highly discriminating way.

Unlike France, which after the majority of Louis XIV began increasingly to employ native painters, much of the greatness of Italian seventeenth-century painting depended on the movement of major painters from one centre to another: Roman Baroque painting is entirely the creation of outsiders—Caravaggio, Annibale Carracci, Lanfranco, Pietro da Cortona, Baciccio—while Neapolitan painting was revolutionized by Caravaggio's visit, and Florence by the presence of Cortona and, later, Luca Giordano. A greater internationalism was evident in the interest shown by non-Italian patrons in contemporary artists such as Reni, Guercino, Dolci, Giordano or Maratti, and by the visits of important painters such as Gentileschi or Romanelli to foreign courts. Notably in papal Rome, an artist's success depended on his birthplace: Gregory XV was Bolognese and favoured

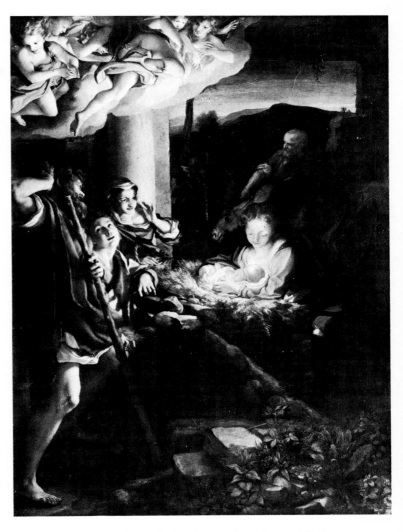

2. Antonio Allegri, called Correggio (1489–1534): *The Nativity* (*La Notte*). 1529–30. Panel, 256.5 × 188 cm. (101 × 74 in.) Dresden, Gemäldegalerie

painters from his native Emilia, while Urban VIII's Tuscan origins favoured the rise of Cortona and Bernini. The principal concern of the popes was with contemporary art, while the Medici Grand Dukes were particularly zealous in assembling earlier masterpieces, and were amply furthered in this by the marriage in 1637 of Ferdinando de' Medici to Vittoria della Rovere, whose dowry contained some of the finest Renaissance pictures in existence.

11

Of the provincial cities, Bologna can lay strongest claim to having retained her autonomy as an artistic centre despite the power of Rome, although as deeper study is made of the Baroque it may emerge that provincial painting exercised a greater influence on Rome than has been suspected. While Naples and Florence both evolved local schools of considerable importance, as did Genoa with greater outside influence, Venice's position declined sharply at the end of the sixteenth century and she produced no major native talent during the Baroque period. It was from Venice, however, that much of the inspiration for Baroque painters emerged: the Venice of Titian, Veronese and Tintoretto. If the seventeenth century rejected the Mannerism of Florence and Rome, it welcomed with open arms the experiments with colour and light made in Venice and Parma during the Mannerist period. No style develops in a vacuum, and in Walter Friedlaender's words, 'Every revolution turns into an evolution if one assembles the preceding storm signals in a pragmatic way.' More than any other painter, Correggio prefigures the Baroque.

Almost all of Correggio's major paintings after 1520, notably his two dome frescoes in Parma, became the objects of pilgrimage for seventeenth-century artists (Plates 30 and 57). Of his many magnificent altarpieces, *La Notte* or *The Nativity*, painted for a family chapel in Reggio Emilia from 1529 to 1530 (Plate 2) contains the germ of so much Baroque painting. Intimate and natural without being a *genre* painting, its combination of dramatic artificial lighting (actually emanating from the Christchild) with brilliantly observed gesture—notably that of the girl who hides her face from the light—can only be called proto-Baroque. The sharp diagonal leading the eye towards the Madonna, and the total absence of Mannerist artificiality, combine with Correggio's peculiar 'softness' (which Vasari so

admired) to make this the antecedent of many later paintings. Hegel, in his *Aesthetics*, points out that, while Raphael evokes the Antique by 'an open and serene clarity and representational accuracy', Correggio was superior in the magical charm of his light and shade, his delicacy and spiritual grace, his forms, movements and the disposition of his groups. More than in Michelangelo or Raphael, both of whom they revered, the Baroque artists saw in Correggio that illusion of warmth and naturalness with which they could identify.

While Correggio's style naturally presented a preferable alternative to that of the Mannerists, the Venetians—especially Titian and Veronese—offered a particularly alluring combination of colour, light and atmosphere. In 1583, the date of Veronese's *Apotheosis of Venice* (Plate 3), Titian was only recently dead (1576) and Tintoretto was to survive until 1595. Veronese's paintings offered a more worldly alternative to those of Correggio: this magnificent allegory of Venice typifies that cornucopian profusion of Veronese's art which was to fascinate the Baroque painters. Pearl-skinned women in vibrant silks, satins and velvets, offset by bronzed heroes in shining armour, are all shown in a vertiginous architectural setting artificially tilted to permit us to see more of the figures than is visible in Correggio's perspectivally more accurate domes. Veronese, however, despite being cautioned by the Inquisition on account of this very *embarras de richesses* made no real contribution to Counter-Reformation painting. The first Italian painter of any importance who did, and who might be said to have been trapped between the Mannerist and Baroque periods, was Federico Barocci of Urbino.

3. Paolo Veronese (About 1528–88): *The Apotheosis of Venice*. 1583. Canvas 904 × 580 cm. (335 × 227 in.) Venice, Ducal Palace

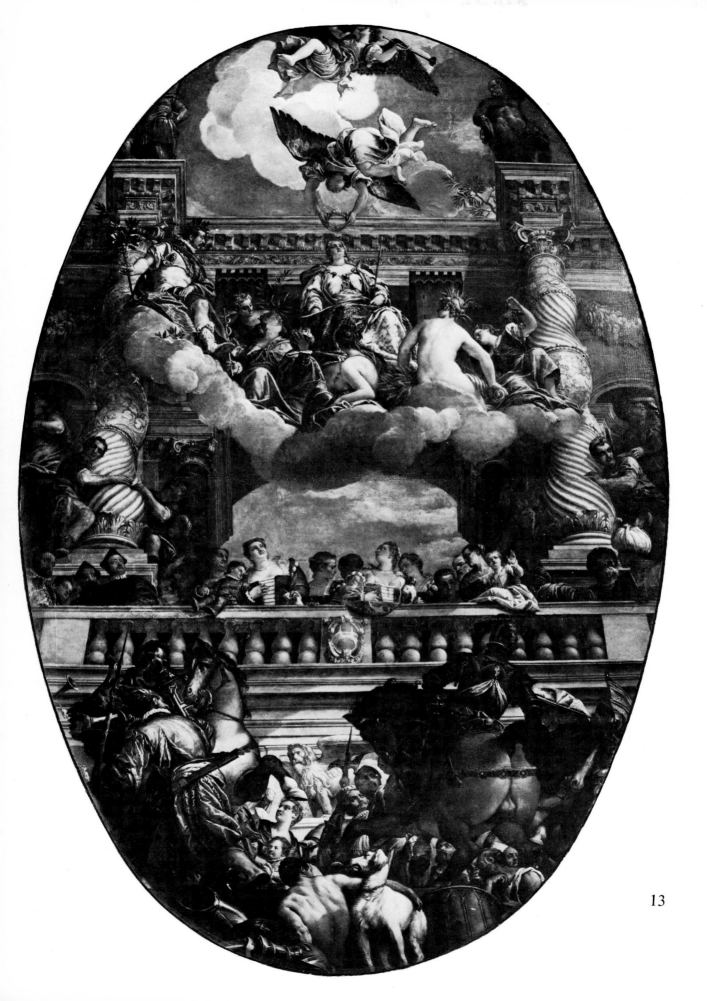

13

Barocci's delicate sensibilities, combining the ecstatic and sensuous aspects of Correggio with a fidelity to the living model, place him at the head of the tradition first codified by the Carracci. How far his imagery is from the pedantic narrative which the Counter-Reformers really preferred, can be seen in his great *Madonna of the People* (Plate 4). Barocci returned to a practice largely abandoned in Italy after the High Renaissance—the careful preparation for a composition through many studies of the model—and more than two thousand of his exquisite chalk drawings survive. Another of his practices, which later became a Baroque norm, was the use of *bozzetti*, or small oil studies, for the finished composition, which would give artist and patron alike some idea of how the completed painting would look. The most striking feature of the *Madonna of the People* is the close inter-relationship of the earthly with the heavenly. Mothers, children, beggars, animals and a large crowd of ordinary people are seen in close proximity to Christ and the Virgin, all without any sense of the inappropriate or the absurd; Caravaggio took this to its extreme in his *Madonna of Loreto*, where the main distinction between the kneeling beggars and the Madonna is the latter's halo. Barocci is too original to be categorized as merely proto-Baroque, and certain features of his art, such as his 'shot' colours, look back to early Mannerism. But his dramatic lighting and strong diagonals link him directly with Cortona and Baciccio. His *Blessed Michelina Mitelli* (Plate 5) strongly reflects the mood of his time, and the ubiquity of his commissions from Genoa to Rome and Perugia ensured his widespread influence.

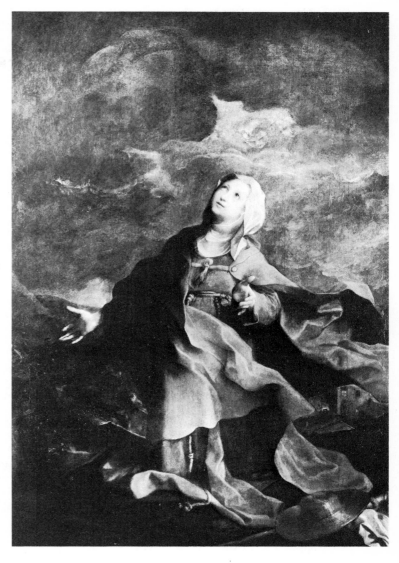

4. Federico Barocci (About 1535–1612): *The Madonna of the People*. 1575–9. Panel, 359 × 252 cm. (141½ × 99¼ in.) Florence, Galleria Uffizi

5. Federico Barocci (About 1535–1612): *The Blessed Michelina Mitelli*. 1606. Canvas, 252 × 171 cm. (99 × 67¾ in.) Rome, Pinacoteca Vaticana

The term 'Baroque' should be broken down into two sub-divisions. The classical and Baroque strains run perceptibly through seventeenth-century art, sometimes clearly parallel, often inseparably mixed. Bellori, in his *Lives of the Modern Painters*, published in Rome in 1672, says: 'when painting was drawing to its end [i.e. in the hands of the Mannerists], other, more benign influences turned towards Italy. It pleased God that in the city of Bologna, the mistress of sciences and studies, a most noble mind was forged and through it the declining and extinguished art was reforged. He was that Annibale Carracci. . .'. Annibale (1560-1609) was, with Caravaggio, the painter to whom the invention and evolution of the early Baroque style can be accredited. Bellori, whose *The Idea of the Painter, Sculptor and Architect* was the seventeenth century's most authoritative statement of classical art theory, naturally favoured Annibale, not Caravaggio. The artist's *duty*, says Bellori, is to select the most beautiful individual parts of an object and combine them to create a form which is automatically more perfect and therefore more beautiful than anything in nature. This originated in the Pliny-Cicero story of the Greek painter Zeuxis's creation of the portrait of Helen of Troy from the best parts of the five most beautiful girls of Croton. The dependence of the artist on Classical sculpture was thus a *sine qua non* of success. Bellori was drawn to the painting of Raphael, as were Annibale, Reni, Domenichino and Maratta in Bellori's own day (Plates 8, 12, 23, 24 , 65). For Bellori, Annibale was automatically the 'hero' of his *Lives*, much as Michelangelo had been for Vasari, and Bernini was to be for Baldinucci.

A glance at the plates in this book reveals that Raphael was not Annibale's only inspiration. In 1582, Annibale had founded in, his native Bologna, together with his brother Agostino and their cousin Lodovico, an Academy of 'Nature' or 'Drawing' to provide nude models for the guidance of young painters. The importance of this lay in the fact that while Vasari had founded his academy to give artists increased social status, the Carracci academy was to be a meeting place where artists could use the model and discuss their art among themselves. This prepared the way for others of its type, founded by Guercino, Albani and Canuti, and by the end of the seventeenth century such academies also met in the palaces of patrons such as the Ottoboni, Sacchetti and Falconieri. When Annibale left Bologna for Rome in 1595, the academy was maintained by Lodovico, and from it emerged the leading classical 'Bolognese'—Guido Reni, Domenichino and Francesco Albano.

Annibale's devotion to the model, and to the 'real' appearance of everything (recalling Paleotti's dictum), led him to begin his career with paintings of extraordinary energy and almost crude intensity, such as the famous *Butcher's Shop*, in which, so legend has it, he painted the portraits of his family (Plate 6). This, the *Bean-Eater* (Rome, Colonna Gallery) and a *Crucifixion with Saints* (Bologna, Sta. Maria della Carità) were all painted at the same time as Veronese's *Apotheosis of Venice* (Plate 3), but could not be more different. Between then and 1588, Annibale travelled in Tuscany, Lombardy and Venice: the result was a precociously profound assimilation of the works of Raphael, Titian, Veronese and Barocci, which enabled him to produce what has been called 'the first Baroque picture'—his *Pietà with Saints* (Plate 7) of 1585. It is an image which Paleotti might well have approved for its meaningful and expressive gesture, its simple narrative and its dignity—based on a careful study of the greatest masters. Although obviously the result of a close observation of reality, its idealization is such that the spectator automatically keeps a respectful distance;

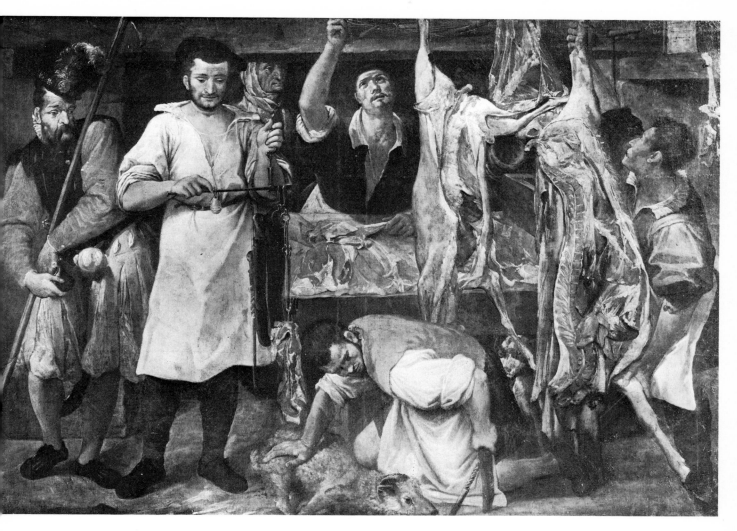

6. Annibale Carracci (1560–1609): *The Butcher's Shop*. About 1582–3. Canvas, 190 × 171 cm. (75 × 67⅜ in.) Oxford, Christ Church

he is both directly involved and uplifted.

By 1595, Annibale had progressed through a series of altarpieces, each of which shows a developing understanding of his chosen exemplars. In characterizing the borrowings of the Carracci as 'eclectic', their detractors entirely missed the point of their painting, for Raphael and Michelangelo had arrived at their own individual styles by the same means. Annibale's move to Rome, where he 'had been anxious to go' in order to study 'Raphael and the works of Antiquity' (Bellori), brought his style to maturity. He can little have imagined that in the service of the Farnese family there he would create a decorative ensemble destined to be compared with the Raphael Stanze and the Sistine Ceiling. The Farnese Gallery (Plate 8) is certainly a far more beautiful interior than either, and apart from alterations in the sculptures, is entirely as Annibale left it. A sparkling assembly of frescoes and decorative plasterwork, the room's theme is, according to Bellori, that favourite of Renaissance neo-Platonism, the conflict of earthly and celestial love. Whatever the precise meaning of the frescoes, their subject-matter is entirely pagan and is centred around the principal ceiling fresco, *The Triumph of Bac-*

17

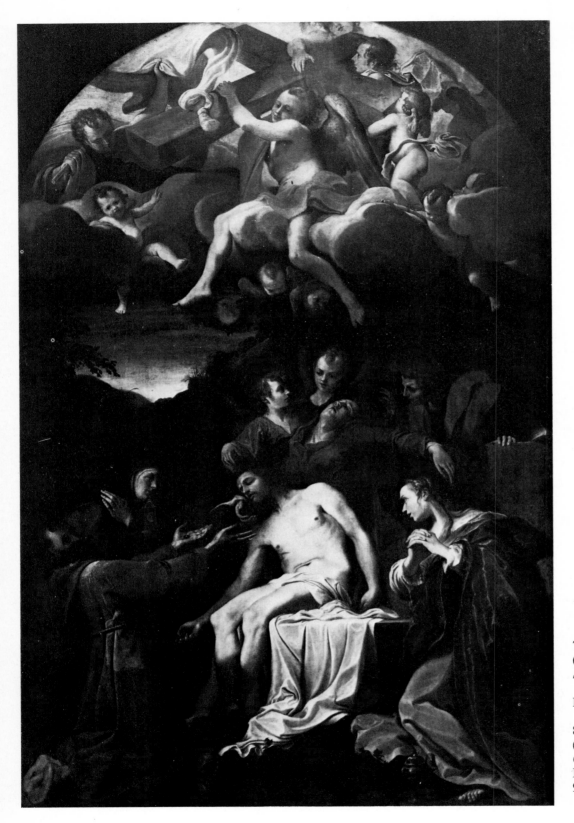

7(*left*). Annibale Carracci (1560–1609): *The Pietà with Saints*. 1585. Canvas, 374 × 238 cm. (147¼ × 93¾ in.) Parma, Galleria Nazionale

8(*right*). Annibale Carracci (1560–1609): *The Farnese Gallery*. About 1597–1604. Interior, 20.14 × 6.59 × 9.8 m. (66 × 21½ × 32 ft.) Rome, Farnese Palace

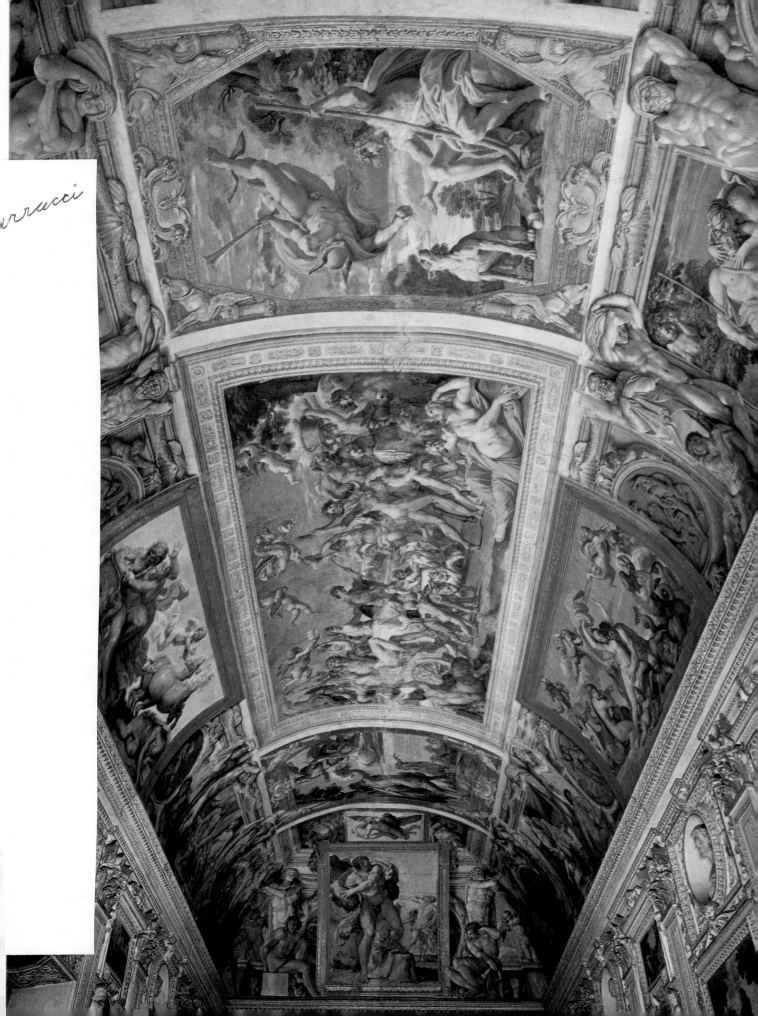

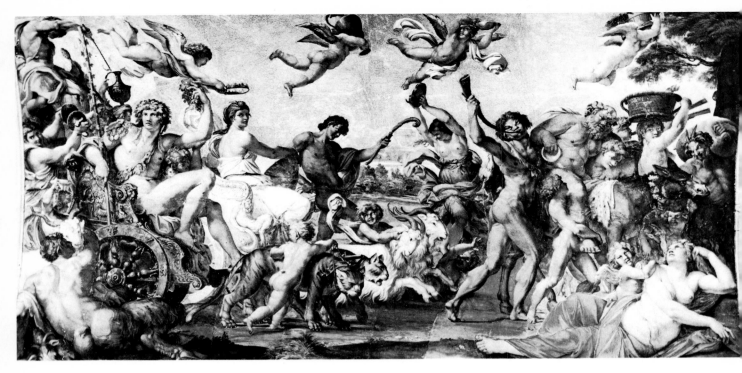

9. Annibale Carracci (1560–1609): *The Triumph of Bacchus and Ariadne*. About 1597–1600. Fresco. Rome, Farnese Palace

chus and Ariadne (Plate 9), for which, along with the entire cycle, Annibale made many preparatory drawings (Plate 10). Although the series would certainly have qualified among the 'indecent and lascivious' paintings attacked by Paleotti, its vitality and innovatory energy unite Raphael with the Antique in an utterly unpedantic way. They were painted for a cardinal, but only one voice of dissent—that of La Bruyère—appears to have been raised against the frescoes in the seventeenth century. The perfection of each of the forms was achieved by experimentation through the many studies, which led the connoisseur Mariette to call Annibale 'without doubt one of the greatest draughtsmen of all time' in 1741.

The importance of the Farnese Gallery decorations lies as much in their immense

10. Annibale Caracci (1560–1609): *Study of a Girl with a Basket*. About 1598. 42.6 × 28.7 cm. (16¾ × 11¼ in.) Paris, Louvre, Cabinet des Dessins

influence as in their intrinsic greatness. Their wide range of references to the Antique and their many precise archaeological quotations, coupled with rich colour and surging movement, were taken up by Rubens and Bernini and all the major decorators of the Baroque, including Lanfranco, Cortona, Baciccio and Giordano. No other century has opened with a more optimistic celebration in paint of the beauty of the visible world. Within a few years, however, Annibale's reflective and even solitary nature led him to a colder classicism and even more deliberate compositions, in which the robust exuberance of the gallery is replaced by a cerebral monumentality (Plate 12). If the Baroque of Cortona derives from the gallery frescoes, the classicism of Sacchi and Poussin stems from Annibale's latest works. Indeed, the simple grandeur of *Domine, Quo Vadis?* finds no equal until Poussin, whose carefully constructed landscapes it also prefigures. Arcadian landscape was one of the principal innovations of Annibale's last years, and Constable, in his 1833 *Lectures on Painting*, noted that 'Annibale's landscape, although severe, is spacious and poetic . . . adapting itself marvellously to the fauns, satyrs and other mythological creatures who enliven it.' Part of a series of six lunettes for the Chapel of the Aldobrandini Palace in Rome, Annibale's *Flight into Egypt* (Plate 11) has a broad simplification of form which liberates it from sixteenth-century landscape convention and heralds the dawn of the classical landscape tradition which culminates with Claude Lorrain. A 'shifting,

11. Annibale Carracci (1560–1609): *The Flight into Egypt*. About 1604. Canvas, 122 × 230 cm. (48⅛ × 90 in). Rome, Galleria Doria Pamphili

cool light' explores the verdant slopes around a huge Roman citadel, while, by a system not unlike theatrical wings, Annibale leads our eye into the hazy Mediterranean distances beyond.

According to Malvasia in his study of the Bolognese painters, Annibale went to Naples in 1609 to seek death, being 'almost tired of living', but returned to Rome in an emotionally disturbed condition and died there. Only one year later, Caravaggio died of malignant fever on his way back to Rome and a papal pardon for his misdemeanours. Having arrived in Rome from Lombardy in about 1592, at the age of twenty-one, he was forced to flee after committing a murder in 1606. Telescoped into this brief period was a development far more dramatic and revolutionary than Annibale's, with which none the less it shared certain similarities. Caravaggio worked first as a journeyman painter, and apparently went through severe misfortune before establishing his reputation in the later 1590s. Having studied with Cavaliere d'Arpino, the leading late Mannerist then active in Rome, Caravaggio might have become another purveyor of Arpino's anaemic style, had it not been for his Lombard background and his fiery, difficult temperament. As in Annibale's case, Caravaggio's native region provided many examples of the work of resident Northern realists, together with the paintings of Savoldo and other painters interested in light-effects. Ironically, while Annibale—ostensibly the classicist—achieved a directness amounting almost to caricature in his early work, Caravaggio immediately began to use light and surface realism to achieve a certain glamour in his first scenes of fortune-telling, indolent, androgynous youths and narcissistic self-portrayals as Bacchus in varying stages of inebriation. A psychological complexity appears even in these early paintings, however, which is alien to Annibale's art; an

extension of Caravaggio's narcissism may even be seen in his devotion to the pictorial values of flesh, hair, fabrics and even light itself, which he begins to use as an almost tangible factor in his paintings after 1597. From the beginning, light falls on his figures from unseen sources, with the result that the figures—which usually fill their canvases to bursting-point (Plate 14)—achieve a solidity and a tangibility that is frequently disturbing. Light—later to play such an important role in the illusionistic tricks masterminded by Bernini and the High Baroque—is endowed by Caravaggio with a mysterious, divine life of its own. It almost entirely takes the place of the beatific visions of other Baroque painters.

The often shocking directness of his results (so far as we know, he never made a single preparatory drawing), his apparent anti-classicism and his violent nature made him extremely difficult for his contemporaries to understand. Bellori attacked his lack of idealization in the Annibale manner, asserting that 'the moment the model was taken away from his eyes, his hand and his imagination remained empty', but admitted that 'he advanced the art of painting because he came upon the scene when realism was not much in fashion. . .[and] induced his fellow painters to work from nature.' The rejection by the clerics of San Luigi dei Francesi of his first version of *St Matthew writing the Gospel* (destroyed, formerly Berlin, Kaiser Friedrich Museum) because it showed a patently illiterate, coarse saint having a writing lesson from a too-charming angel, typified the reaction of the very people the artist sought to please. An art ostensibly for the people was in

12. Annibale Carracci (1560–1609): *Domine, Quo Vadis?* About 1602. Panel, 77.4 × 56.3 cm. (30½ × 22⅛ in.) London, National Gallery

fact only appreciated by the usual small group of enlightened connoisseurs such as Cardinal del Monte.

Caravaggio's style immediately prior to the paintings which placed him on an equal footing with Annibale, 'The Story of St Matthew' in San Luigi, is best seen in his *Supper at Emmaus* (Plate 14). We are irresistibly drawn into the drama by the outstretched arms, and by the positioning of the seated man to the left in 'our' space, along with the basket apparently about to fall from the table. All our preconceptions about the limits of a flat, painted surface are deliberately upset, an effect further enhanced by the hallucinatory clarity of every detail: Caravaggio painted some of the seventeenth century's greatest still-lifes. In the place of the classical grandeur of the High Renaissance and of Antiquity, he attempted to convey divinity through innate human dignity as transformed by light. Only through light are we made aware of anything supernatural in *The Calling of St Matthew* (Plate 13), where the seated participants are in contemporary dress and the most important figure—Christ, at the extreme right—is hardly visible at all except as the source of light. The importance of gesture and facial expression as externalizations of states of mind—the so-called *affetti* later studied with scientific precision by Poussin and the French academics —is thus as great in Caravaggio as it is in Annibale. Caravaggio's interest in this most typical of all Baroque devices is seen in extreme form in his horrific *Medusa* or his *Sacrifice of Isaac* (both in the Uffizi)—reinterpreted by Artemisia Gentileschi with even greater realism (Plate 17).

Only Caravaggio's use of light and recognizably real models convinces us that his world is any less artificial than Annibale's, while it is in fact arguably more so. The pervading 'dark brown atmosphere of an enclosed room, using a high light that descended vertically over the principal parts of the body while leaving the remainder in shadow' (Bellori) results in a pictorial selectivity which is entirely the artist's and has little to do with the spectator's. Caravaggio's refusal to study ancient statuary or Raphael did not preclude his using the same sources as the Bolognese and achieving comparable effects of grandeur (Plate 16). In *The Deposition* (Plate 15) and *The Death of the Virgin* (Paris, Louvre), which latter Rubens understood enough to purchase for the Duke of Mantua, Caravaggio passed through a brief phase of grandiloquent spaciousness probably not entirely due to intuitive perception of the qualities so admired by Annibale in the High Renaissance. *The Deposition* also represented a brief departure from the brutal ugliness of his other important commission of the early years of the century, *The Crucifixion of St Peter* and *The Conversion of St Paul* (a combination of themes derived from Michelangelo) in the Cerasi Chapel of Sta. Maria del Popolo. Again, *The Death of the Virgin* was attacked because the Madonna's figure 'imitated too closely the corpse of a woman'.

After the duel in which he killed a certain Tomassoni, Caravaggio fled from Rome, passing through Naples in 1606/7, Malta in 1608 and southern Italy and Sicily in 1609. In each of these places he left paintings destined to exert considerable influence on local artists: *The Seven Acts of Mercy* in Naples, *The Beheading of St John* in La Valletta, and *The Raising of Lazarus* for the Church of the Crociferi at Messina (Plate 16). This was his last great masterpiece, and it has a mystical quality utterly different from the somewhat hard, popular religiosity of his Roman works and surely indicative of a profound change in his character. The inimitable technique, using long dry striations of paint which suggest a relief sculpture, comes closer to abstraction than at any other time in the artist's life.

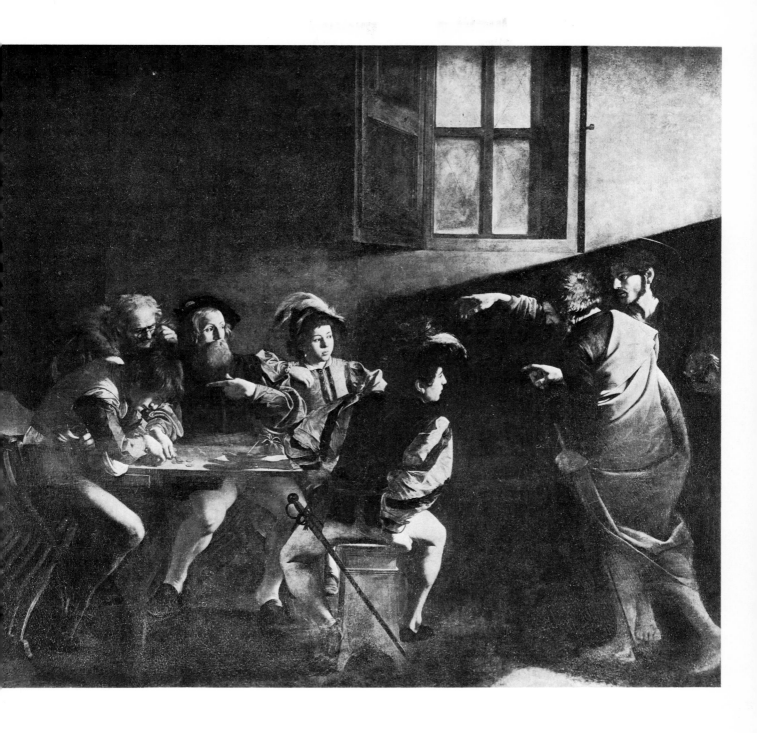

13. Michelangelo Merisi, called Caravaggio (1573–1610): *The Calling of St Matthew*. About 1599. Canvas, 315 × 315 cm. (124 × 124 in.) Rome, S. Luigi dei Francesi

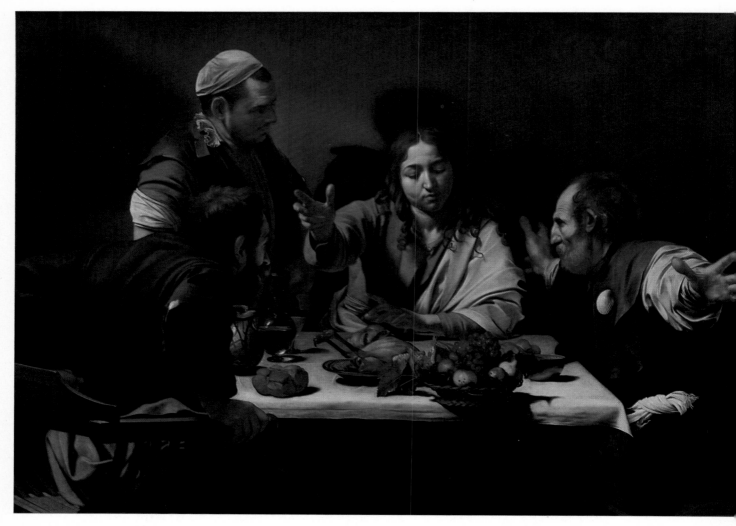

14. Michelangelo Merisi, called Caravaggio (1573–1610): *Supper at Emmaus*. About 1602. Canvas, 141 × 196 cm. (55½ × 77⅛ in.) London, National Gallery

Caravaggio's influence was, understandably, more instantaneous and far-reaching than Annibale's, although he had no pupils in the Carracci sense. His style, especially in the Roman and Neapolitan pictures, was much more accessible and less daunting than Annibale's learned, idealized manner. Few artists, not even the Bolognese (Plate 24), remained impervious to it, though its effects vary greatly on different individuals and schools. Pictures whose debt to Caravaggio does not immediately spring to mind are none the less inconceivable without his influence (Plates 25, 32, 55, 69). A comparison of Manfredi's *Chastisement of Cupid* (Plate 21) with Artemisia Gentileschi's *Judith Beheading Holofernes* (Plate 17) or Coccapani's *Sleeping Girl* (Plate 20) reveals something of the rich variety of personal interpretation possible under the heading of 'Caravaggism'. While the Neapolitans often preferred to draw on Caravaggio's renderings of the human body at its least appealing, the Florentines heightened their already nascent love of dazzling

15. Michelangelo Merisi, called Caravaggio (1573–1610): *The Deposition of Christ*. 1602–3. Canvas, 300 × 203 cm. (118 × 80 in.) Rome, Pinacoteca Vaticana

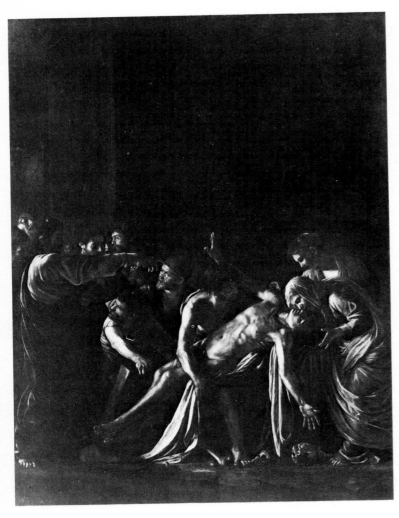

fabrics contrasted with crisp, white linen by studying Caravaggio's superlative technique in painting them. The Italian followers of Caravaggio (as distinct from all those painters throughout the seventeenth century whose use of *chiaroscuro* ultimately derives from him) can be divided into two main groups—those who worked in Rome during Caravaggio's stay there, or shortly after his departure, and those who came into contact with his style in Rome or Naples after his death.

Orazio Gentileschi (1563-1639) belongs to the first group, and actually knew Caravaggio personally. Gentileschi was Pisan, but worked in Rome from 1576 until 1621, when he left for Genoa at the invitation of Giovanni Antonio Sauli. After two years there, he went to Paris and then to London, where he remained for the rest of his life. The Genoese biographer Soprani tells us that the most beautiful of Gentileschi's paintings for Sauli was a *Danaë with Jove in a Shower of Gold* (Plate 18). One of the masterpieces of Caravaggism, its combination of emerald, blood-red, gold, champagne and white, and its crystalline nude, mark it out as much more glamorous than anything by Caravaggio himself, and entirely characteristic of Gentileschi at his best. This type of picture derives more from the Caravaggio of the splendid *St Catherine of Alexandria* (Lugano, Thyssen Collection) of the later 1590s; Caravaggio's later style proved too much for Gentileschi, although the latter's daughter, Artemisia, produced her masterpiece in the style of Caravaggio's most violent and realistic Roman paintings (Plate 17). She was just as peripatetic as her father, and moved to Florence in 1614 after being involved in a famous rape

16. Michelangelo Merisi, called Caravaggio (1573–1610): *The Raising of Lazarus*. 1609. Canvas, 380 × 275 cm. (149½ × 108½ in.) Messina, Museo Nazionale

17. Artemisia Gentileschi (1593–1652): *Judith Beheading Holofernes*. Before 1620. Canvas, 199 × 162 cm. (77 × 64 in.) Florence, Galleria Uffizi

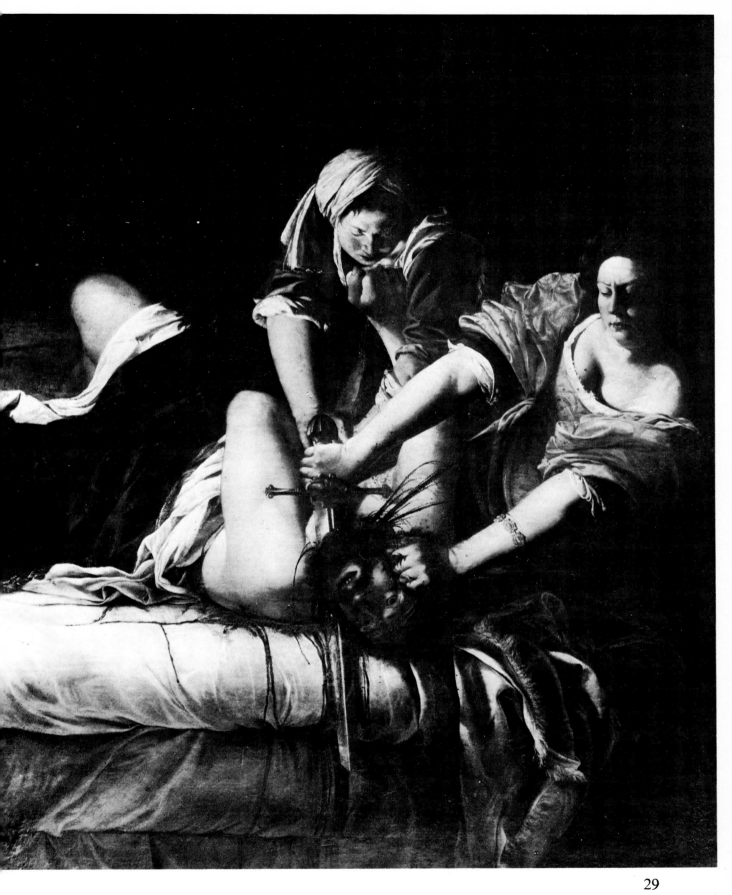

18. Orazio
Gentileschi
(1563–1639):
Danaë. 1621–2.
Canvas, 161.9
× 228.6 cm.
(63¾ × 90 in.)
Cleveland
Museum of Art,
Purchase,
Leonard C.
Hanna Jr
Bequest

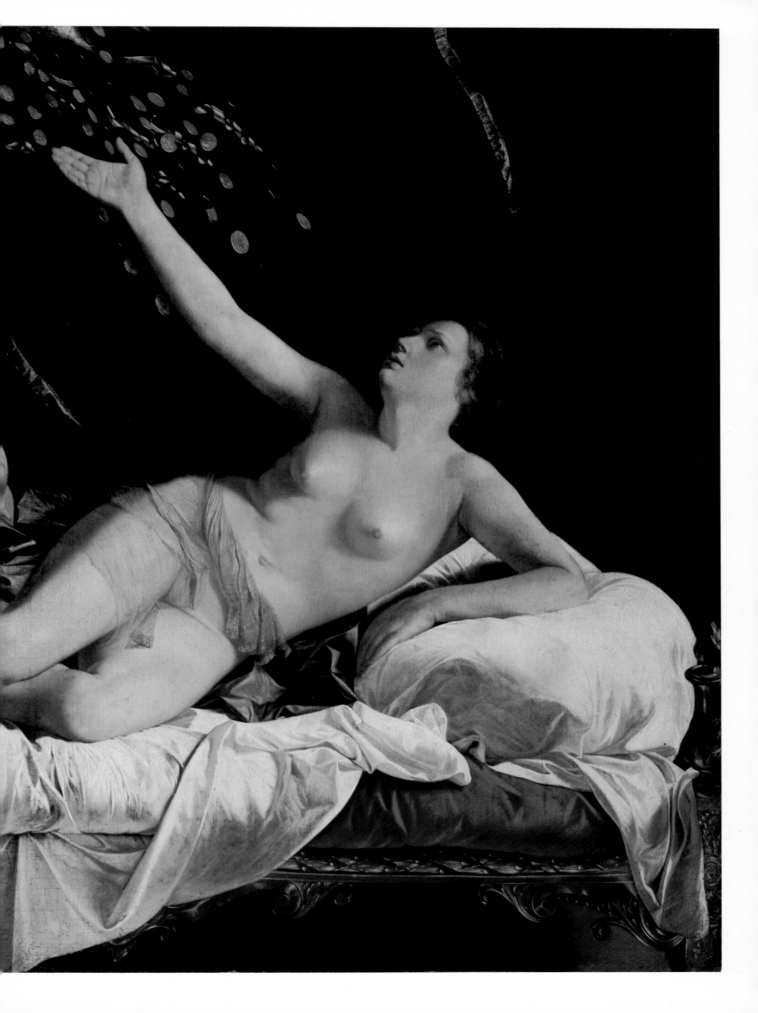

case. She remained there on and off until 1621, working for the Grand Duke and participating in the most important decorative scheme of its day in Florence, in the Casa Buonarroti. Her influence on Florentine painting was considerable, although Caravaggism was firmly established before her arrival there. Subsequently, her travels took her to Rome, Naples and England; there she joined her father before returning to Naples, where she died. In Naples, her position was secondary to that of Ribera and Massimo Stanzione, and her *Annunciation* of 1630 (Capodimonte Museum) shows a falling-off in energy. Like Salvator Rosa, Artemisia became—not surprisingly, in view of the rarity of women painters of quality in this period—something of a legendary figure.

Foremost among the other early followers of Caravaggio was Bartolommeo Manfredi, who was born near Mantua and visited Cremona, Milan and Brescia as a youth. His biographer Mancini also adds that 'he had few public commissions, but painted many private pictures for His Highness of Tuscany.' Mancini and his other biographers all emphasize how close a follower of Caravaggio he was, and that many of his paintings were mistaken for originals by Caravaggio. He was certainly among the most famous artists of his day, and in 1621 some of his paintings were sent to the Duke of Buckingham; but despite this, no single securely documented painting by him is known. His tendency to secularize religious themes recalls Caravaggio's *Calling of St Matthew* (Plate 13), and what Sandrart calls the 'Manfredi manner' exercised a wider influence than that of any of his Italian contemporaries, notably on Northern painters such as Valentin, Nicolas Tournier, Nicolas Régnier and the Utrecht Caravaggists. The violent movement in his *Chastisement of Cupid* (Plate 21) is rare in his work, and more characteristic is the fleshy heaviness of the

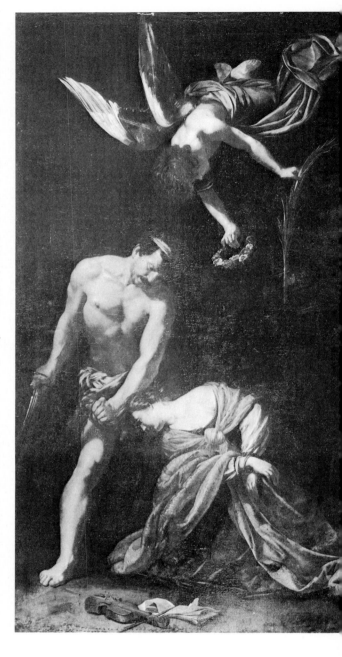

19. Orazio Riminaldi (1586–1631): *The Martyrdom of St Cecilia*. About 1615–20. Canvas, 315 × 171 cm. (124 × 67¼ in.) Pisa, Museo Nazionale

32

figures. The painting's realism is very different from that of Orazio Gentileschi, and it is easy to see why classicizing French painters such as Philippe de Champaigne and Laurent de la Hyre were attracted rather to Gentileschi's more fragile and pellucid manner.

Like Gentileschi, Orazio Riminaldi was Pisan, and according to Baldinucci he admired Domenichino and Manfredi. His *Martyrdom of St Cecilia* (Plate 19), formerly one of the most celebrated of Caravaggesque pictures, was painted for the Pantheon in Rome and later taken to Pisa. While its technique, its violence, and even some features of the composition strongly recall Caravaggio, a certain frozen grandeur clearly points to Riminaldi's interest in more classical painting, Such an amalgam is more characteristic of painting in the third decade of the century, and indicates that Caravaggism was becoming diluted and less closely imitative. Carlo Saraceni, too, although capable of highly concentrated masterpieces in Caravaggio's manner (Plate 22), was perhaps at his most characteristic and pleasing in his spirited, small-scale pictures painted under the influence of Adam Elsheimer.

It is indicative of the richness of Roman culture at the opening of the seventeenth century that two utterly different artistic styles could develop side by side almost contemporaneously, that of Caravaggio and his followers, and that of the Bolognese. Count Carlo Cesare Malvasia's *Felsina pittrice, Lives of the Bolognese painters*, published in 1678, asserted the unquestioned supremacy of painting in that city. It is undeniably true that the Bolognese pupils of Lodovico Carracci were the formative influence on classicism throughout the century, even if the Parmese Giovanni Lanfranco formed the bridge between them and the full Baroque style. Guido Reni was certainly the most sophisticated of the Bolognese, but his immaculate style

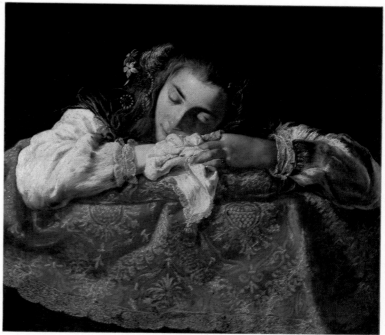

20. Sigismondo Coccapani (1583–1642): *A Sleeping Girl.* About 1630. Canvas, 67.5 × 73.7 cm. (26½ × 29 in.) Budapest, Museum of Fine Arts

21. Bartolommeo Manfredi (About 1580–1620): *The Chastisement of Cupid.* About 1605–10. Canvas, 130 × 175 cm. (68½ × 51⅝ in.) Chicago, Art Institute (Charles H. and Mary F. S. Worcester Collection)

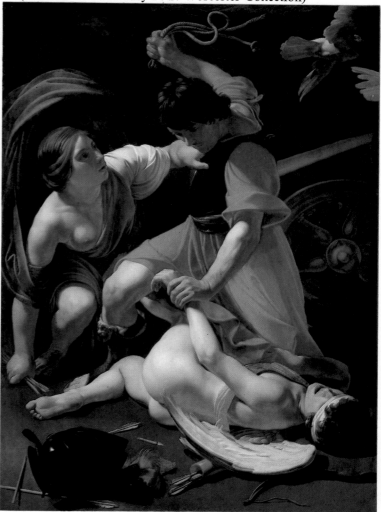

(Plates 24, 28 and 47) reflects nothing of his bizarre personal eccentricities. Despite his handsome appearance, it was 'generally thought that he was a virgin . . . [and that] because of his great devotion, the Virgin deigned to appear before him, he being no less a virgin'. His fear of being poisoned, of witchcraft and of old women, and his melancholic, sexless nature lie behind the endless refinements he brought to paintings such as his early *St Cecilia* (Plate 24). Bellori says that this was painted in 1606 for Cardinal Sfondrato, who had devoted himself to the restitution of the saint's cult after the discovery of her remains in 1599, and who had obtained from Reni a copy of Raphael's *St Cecilia* in Bologna. While Raphael's saint is static and withdrawn despite the presence of other saints, Reni's gazes upwards on the verge of ecstasy, her bow barely touching the strings to suggest an electrically charged intensity, accentuated by the darkness from which she emerges. But if her costume is distinctly Raphaelesque, the background suggests Caravaggio, and in the Vatican *Crucifixion of St Peter* Reni actually imitated the Caravaggio style. St Cecilia's eyes raised heavenwards '*all' armonia*' (in Bellori's felicitous phrase) are among the earliest examples of a particularly Baroque formula for the expression of an inspired or ecstatic state of mind; Barocci's *Blessed Michelina Mitelli*, painted in the same year (Plate 5), shares the same feature in a more extreme, and more Baroque, form. Reni's glacial self-control never allowed him to go to such extremes, and even his later renderings of Cleopatra at the moment of her death are contained by a frozen classicism.

The interest in such early Christian saints as St Cecilia, St Praxedis (a Florentine favourite) and St Vivian (to whom a Bernini church and statue were dedicated) is characteristic of the Catholic Church's move to consolidate its traditional claims to supremacy at this time. In the church of S. Luigi dei Francesi, opposite Caravaggio's St Matthew cycle, Domenichino painted a fresco cycle devoted to the life of St Cecilia (Plate 23), which evokes the period in which the saint lived far more poetically than Riminaldi's painting, for example (Plate 19). This Domenichino achieves by a quasi-archaeological accuracy in the setting, and by the meticulous placing of each figure in a clearly defined space. Annibale had preferred Domenichino to Reni, and had employed him in the Farnese Gallery, where Domenichino had probably developed his love of the type of landscape evolved there by Annibale, which he himself evolved even further (Plate 41). Like Reni, Domenichino appears to have been neurotic, but he remained a strictly classical painter, preparing for his work with copious drawings. Had Reni not preferred to return from Rome to his native Bologna, Domenichino's success might well have been far less; his famous incompatibility with Lanfranco further complicated both his Roman and Neapolitan periods. The St Cecilia frescoes represent Roman classicism at its height, and were painted when Domenichino was in close contact with one of the century's most influential theorists, Monsignor Giovanni Battista Agucchi (Plate 25). Agucchi, who corresponded with Galileo and wrote a treatise on comets, is best remembered for his *Treatise on Painting*, which first codified Baroque classicism and paved the way for Bellori. It is remarkable, however, that the seventeenth century produced no theory which can be called 'Baroque' or which even recognizes or begins to explain the growth of such a style.

Anti-Mannerist experiments in Bologna

22. Carlo Saraceni (1579–1620): *The Miracle of St Beno*. 1618. Canvas, 239 × 178 cm. (94 × 70 in.) Rome, Sta Maria dell'Anima

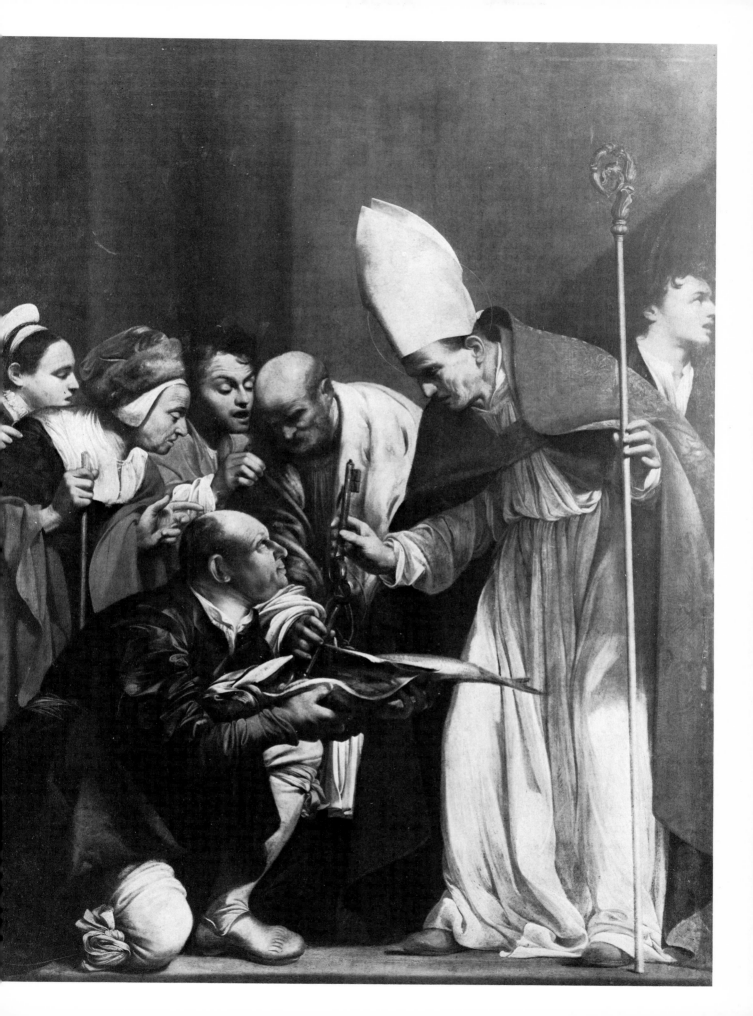

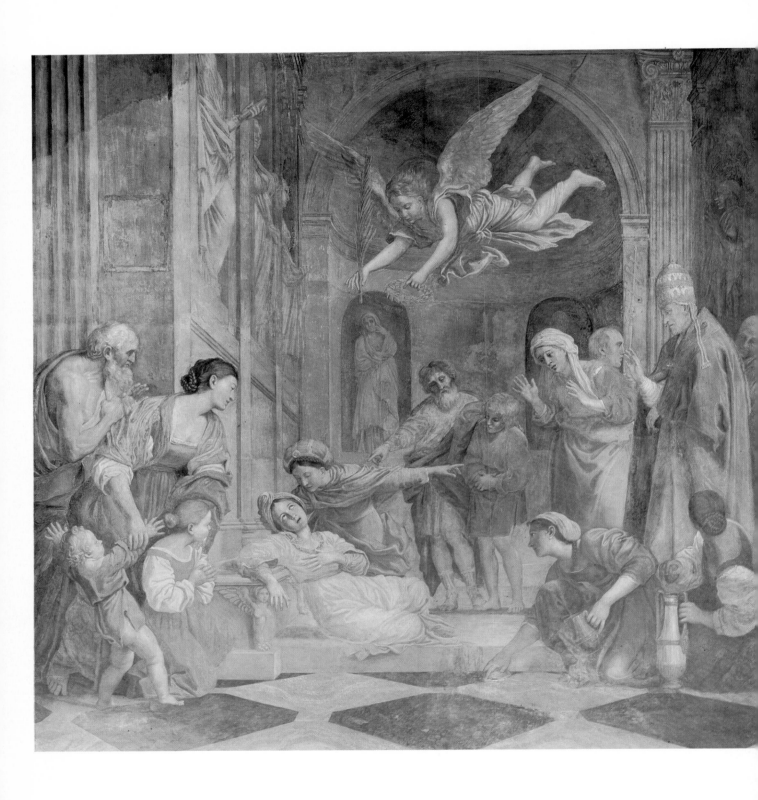

23. Domenico Zampieri, called Domenichino (1581–1641): *The Death of St Cecilia*. 1615–17. Fresco. Rome, S. Luigi dei Francesi

and Rome were paralleled and even pre-figured by the work of certain Florentine artists, who came closer in some cases to being real Counter-Reformation (as opposed to Baroque) artists. Santi di Tito and Jacopo da Empoli—the latter lived until 1640—were basically painters of this type, and it was through the work of their successor, Lodovico Cigoli, that a return to the values of the High Renaissance, such as Annibale had sought, first appeared in a fully developed form in Florence (Plate 26). The real, unrecognized talent of early Baroque Florence was without question that of Cristofano Allori (1577-1621), whose portrait of 'the Florentine Tacitus', Bernardo Davanzati Bostichi (Plate 27)—stylist, theorist and translator—is the equal of anything of its day in Italy. At its best, Allori's was a superb technique, and he was capable of far greater psychological acuity than any of his Florentine contemporaries, as is seen in his *Miracle of the Blessed Manetto* (Florence, SS. Annunziata), *The Hospitality of St Julian* (Florence, Pitti) and *Judith with the Head of Holofernes*, of which two principal, very different versions exist: the earlier and more intense (Plate 32) is signed and dated 1613, while the later in the Pitti is more inflated and grandiose. The story behind the picture, not surprisingly beloved of nineteenth-century Romantics and Decadents alike, of Allori portraying himself as Holofernes held by his cruel mistress *La Mazzafirra* and watched by her mother, is one of the classics of Florentine painting. Allori would undoubtedly have gone on to even finer painting, had he not died in his early forties.

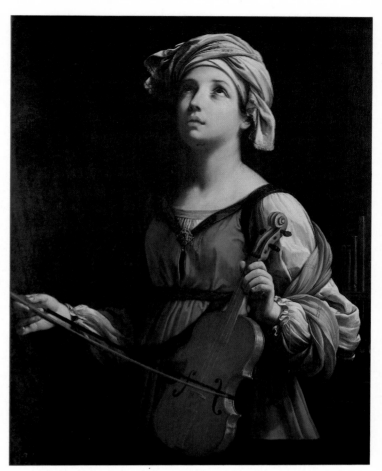

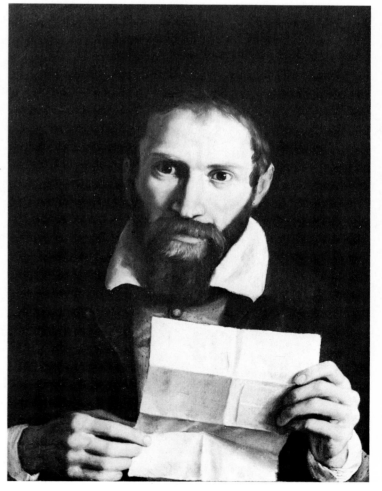

24(*above right*). Guido Reni (1575–1642): *St Cecilia*. 1606. Canvas, 96 × 76 cm. (37¼ × 29½ in.) Los Angeles, Norton Simon Foundation

25(*below right*). Domenico Zampieri, called Domenichino (1581–1641): *Portrait of Monsignor Agucchi*. 1621-2. Canvas, 60.3 × 46.3 cm. (23¾ × 18¼ in.) York, City Art Gallery

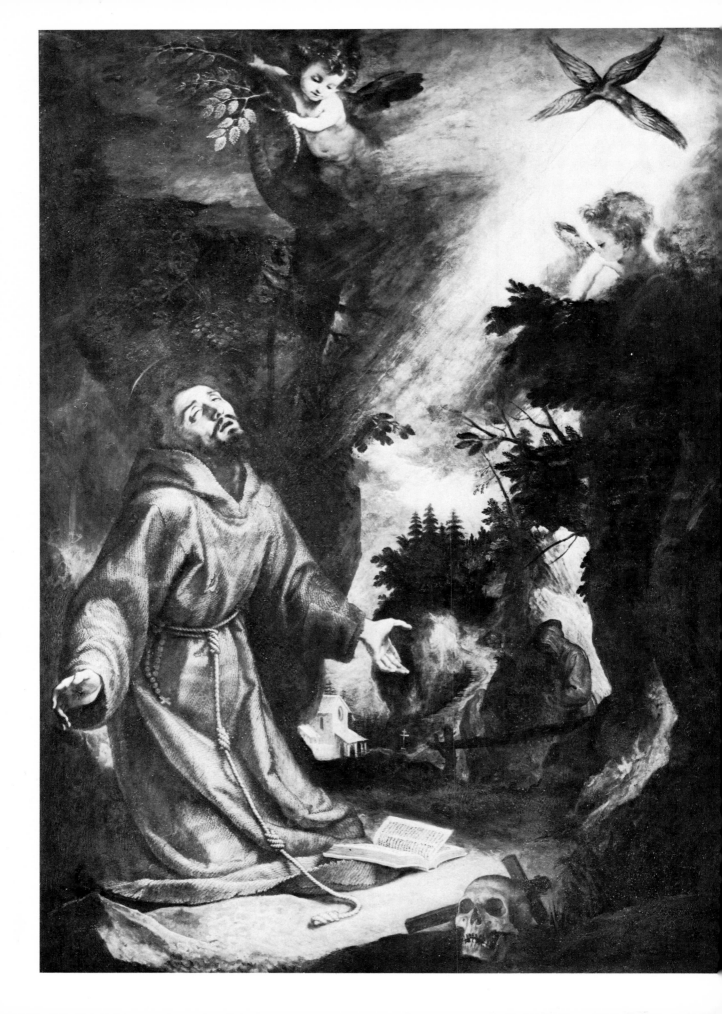

The reaction against the cold classicism of early Reni and of Domenichino—which found little echo in other Italian centres—set in at approximately the same time as Caravaggism began to be diluted, about the end of the second decade of the seventeenth century. Reni himself experimented with a style which can only be termed romantic, best expressed in his *Atalanta and Hippomenes* (Plate 28) of about 1615-25, or in the *Rape of Dejanira* of 1621 in the Louvre, painted for Federico Gonzago, Duke of Mantua. But the most notable development in this direction came in the work of Giovanni Lanfranco, in which all the features of the full Baroque first make their appearance together. Born near Parma, Lanfranco first studied with Agostino Carracci, who was in the service of Duke Ranuccio Farnese in Parma in 1600. It was with Odoardo Farnese that Lanfranco came to Rome in 1602, in time to work under Annibale on the last stages of the Farnese Gallery. In 1607 he published a small volume of engravings of Raphael's *Logge* in the Vatican, together with Sisto Badalocchio. Having received the widest public recognition, Lanfranco was commissioned to decorate the gallery of the Villa Borghese—an important step in the history of illusionistic decoration—and between 1625 and 1627 he frescoed the immense dome of the Roman church of S. Andrea della Valle with *The Assumption of the Virgin* (Plate 30). This and the cupola of the Cappella del Tesoro in S. Gennaro in Naples are the result of a combination of Correggio's style in the Parmese dome frescoes with the dramatic lighting which Lanfranco derived from Caravaggio, but which he used in a much less artificial way. His biographer Passeri pointed out that

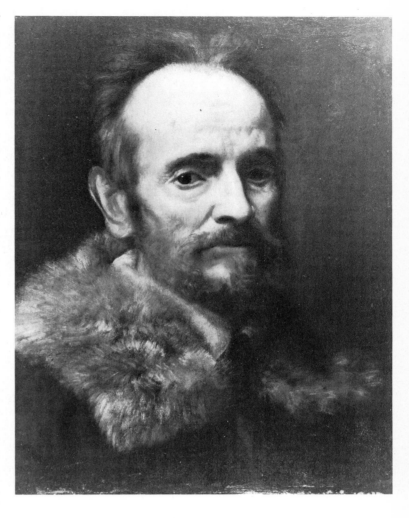

26. Lodovico Cigoli (1559–1613): *The Ecstasy of St Francis*. About 1596. Canvas, 250 × 176 cm. (98½ × 69¼ in.) Florence, Galleria Uffizi

27. Cristofano Allori (1577–1621): *Portrait of Bernardo Davanzati Bostichi*. About 1605. Canvas, 48 × 36 cm. (18⅞ × 14⅛ in.) Oxford, Ashmolean Museum

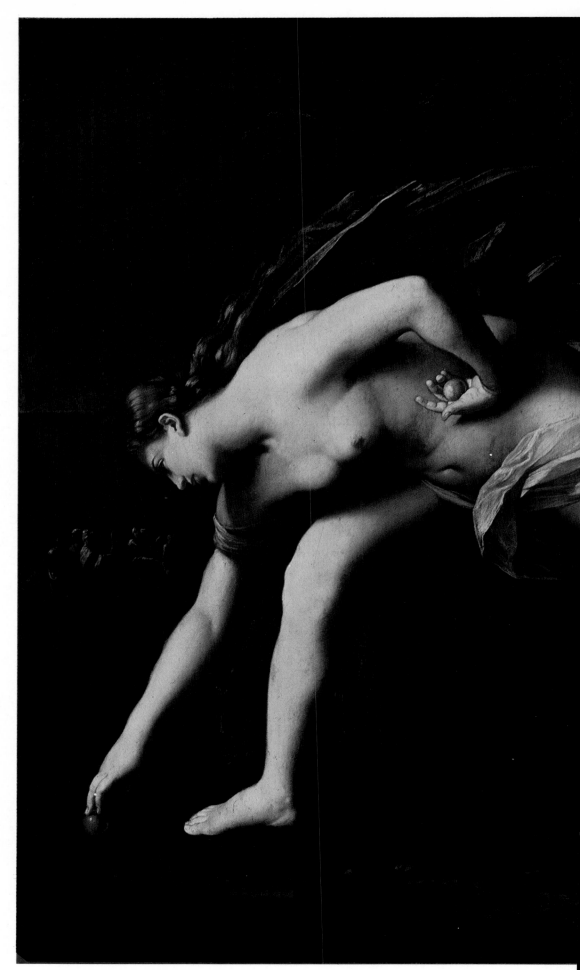

28. Guido Reni
(1575–1642):
*Atalanta and
Hippomenes*.
1615–25.
Canvas, 206
× 297 cm.
(81 × 117 in.)
Naples,
Galleria
Nazionale di
Capodimonte

40

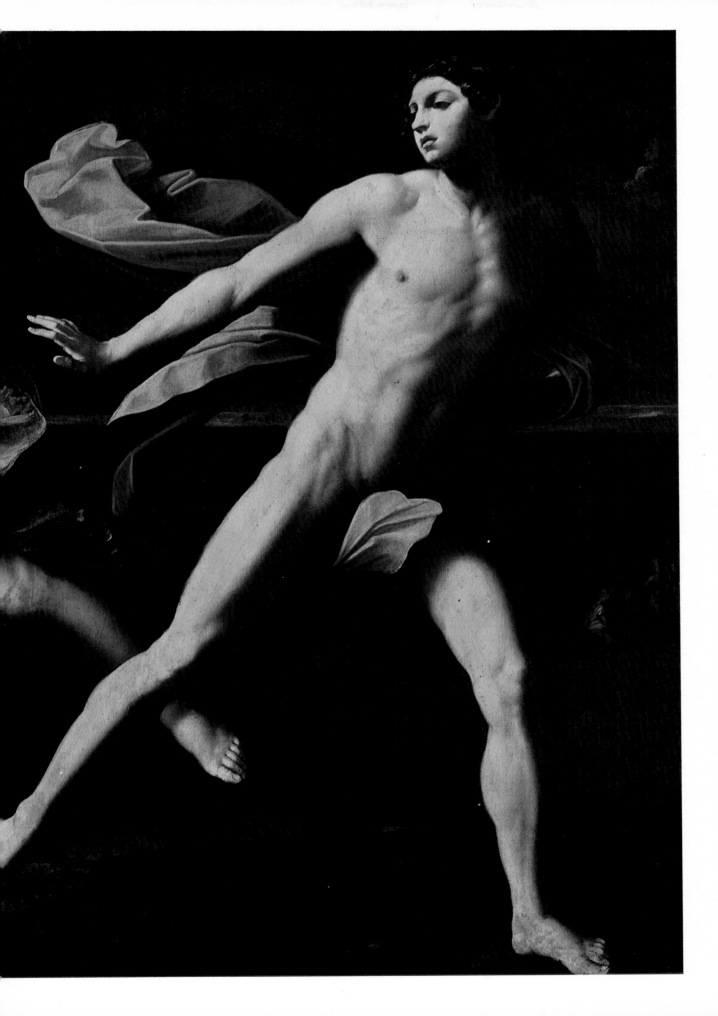

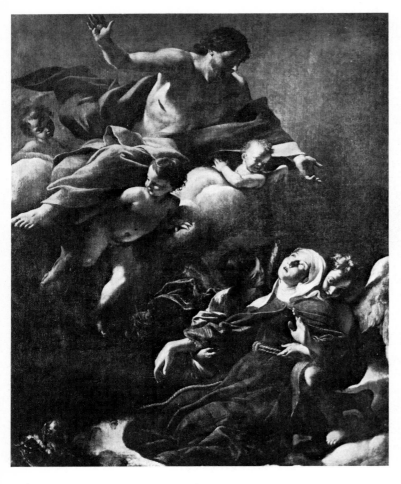

Lanfranco 'was the first to throw open such a celestial glory with the living expression of an immense luminous splendour', and pointed out, with an analogy pertinent to ears accustomed to the music of Palestrina and Monteverdi, that it was as much a mistake to attempt to isolate individual parts in this fresco as to hear a single voice amidst choral harmony.

Lanfranco's particular use of dramatic luminosity, together with fluttering draperies, saintly ecstasy, strong diagonals and the visualizing of experiences presumably only visible to the saint in question—all of these are concentrated in another masterpiece, *The Vision of St Margaret of Cortona* (Plate 29). If Annibale's *Pietà* was the 'first Baroque picture' this Lanfranco marked the opening of the style's second phase, prefiguring as it did by more than two decades Bernini's *St Teresa*. The vigour of Lanfranco's forms (compared, for example, with Reni's *Atalanta* (Plate 28), which, despite its extremes of action, is calm in effect) and the strong reds, blues and greens of paintings such as those for S. Paolo-fuori-le-mure in Rome (Plate 35) or his Neapolitan works after 1634, ensured his immense and still underestimated influence.

If Parmese painting was fundamental for Lanfranco, the next phase of Roman Baroque painting owes its richness to the adoption of Venetian art by the Tuscan, Pietro da Cortona. Cortona, like many other seventeenth-century painters, was also an architect, and was brought to Rome from Cortona by Andrea Commodi in 1612, after studying with local painters. Little is known of Cortona's early style, but the highly decorative tradition embodied in Allori's *Judith* (Plate 32) probably influenced his beginnings. In Rome the impact

29. Giovanni Lanfranco (1582–1647): *The Vision of St Margaret of Cortona*. About 1618–19. Canvas, 236 × 189 cm. (92½ × 74 in.) Florence, Pitti Palace

30. Giovanni Lanfranco (1582–1647): *The Assumption of the Virgin*. 1625–7. Fresco. Rome, S. Andrea della Valle

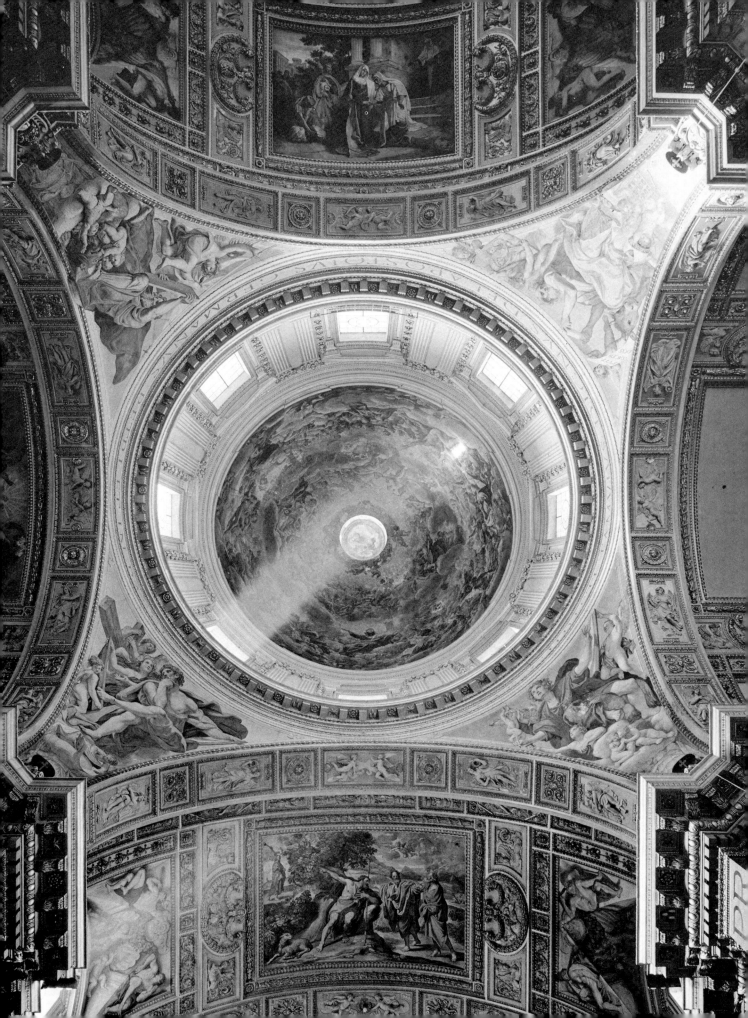

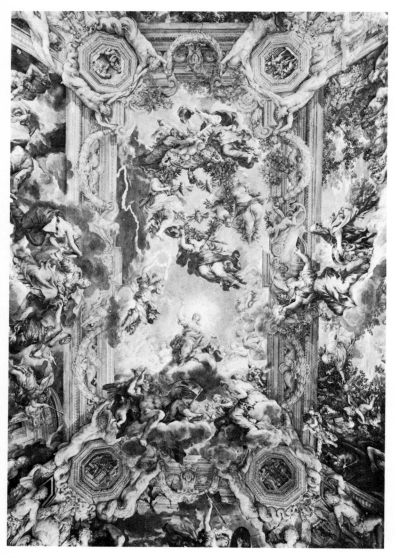

of Caravaggio, the Carracci and the Antique immediately changed his style, and he made drawings after Trajan's Column, Raphael and Polidoro da Caravaggio. Cortona's Tuscan origins gained him an entrée into the circle of the brothers Giulio and Marcello Sacchetti, who were leading figures in Rome's Tuscan colony and intimates of the Barberini. Marcello set Cortona to copy a Titian painting, thus probably consolidating his love of Venetian colourism. This was strengthened by his visit to that city in 1637, when he was in the middle of painting the Barberini Ceiling (Plate 31). In 1797, Francesco Milizia wrote in his *Dictionary of the Fine Arts:* 'Borromini in architecture, Bernini in sculpture, Cortona in painting, the Cavaliere Marini in poetry, represent a diseased taste. . .'. That taste was the fully-developed High Baroque, which, despite the fame of its protagonists as specified by Milizia, cannot ultimately be claimed to have gained the upper hand for very long in Rome.

From his early masterpieces in the Roman church of S. Bibiana (St Vivian) showing the story of the saint and painted immediately after the election of Pope Urban VIII, Pietro da Cortona rapidly developed his grandiose style, which reaches its first culmination in the Barberini Ceiling. While his love of Antique ornament and detail was as great as Domenichino's in S. Luigi (and he learned much from the Bolognese master's lucid compositions), he added a more dynamic exploitation of depth, bulkier forms, and far greater visual excitement in form and colour. Urban VIII's 'spiritual monarchy' and the somewhat hothouse intellectual atmosphere of his court, both at the Vatican and in the immense

31. Pietro da Cortona (1596–1669): *Allegory of Divine Providence and Barberini Power.* 1633–9. Fresco. Rome, Barberini Palace

32. Cristofano Allori (1577–1621): *Judith with the Head of Holofernes.* 1613. Canvas 120.4 × 100.3 cm. (47⅞ × 39½ in.) London , Kensington Pal. , Her Majesty the Queen

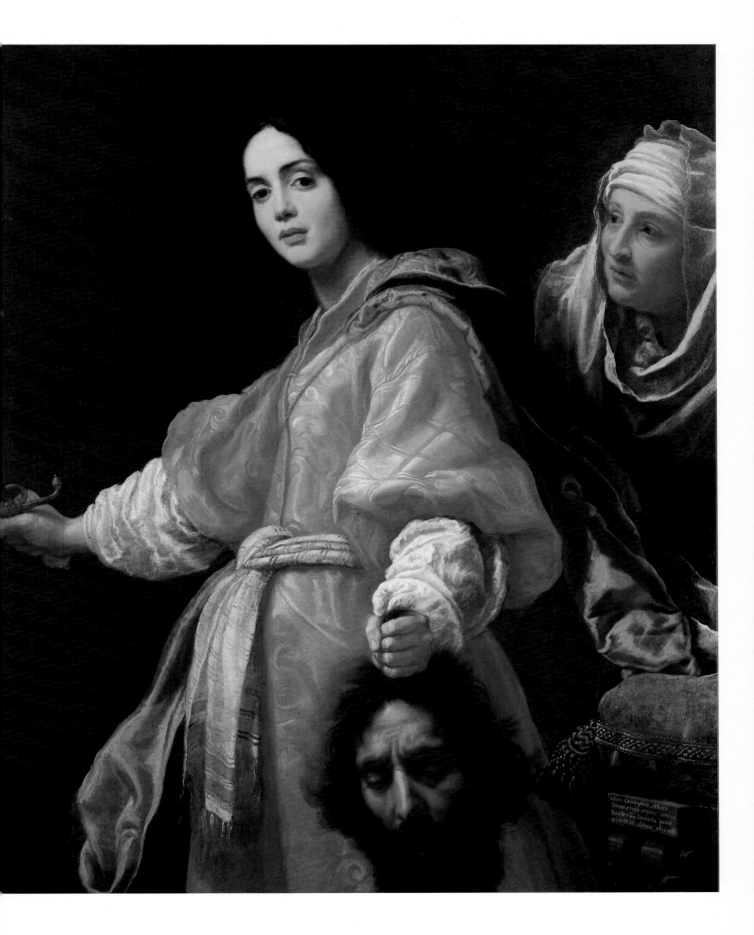

family palace, found their complete expression in the elaborate allegory of the ceiling. Simplified, its message is: 'Urban VIII, the poet-pope, chosen by Divine Providence, and himself the voice of Divine Providence, is worthy of Immortality, whose crown he receives as it were by proxy' (Wittkower).

Although the Barberini Ceiling was immensely influential through its copious invention, its rich colour and its thoroughly up-to-date application of the Antique, Cortona's work for another, possibly more stable, Italian family—the Medici—was, in the long run, to have greater impact. His first commission in the Pitti Palace was perhaps the most concentratedly delightful—the wall frescoes in the Sala della Stufa (Stove Room), whose vault and lunettes had already been painted by the native Florentine, Matteo Rosselli. When Cortona's frescoes were unveiled, Rosselli is said to have exclaimed to another Florentine artist, 'Oh Curradi, how small the rest of us are!' The effect of Cortona's visit on Florentine art has been exaggerated, but the delicate eroticism of the first two frescoes (the theme of the room is the return of a Golden Age with the marriage of Ferdinando de' Medici to Vittoria della Rovere) already prefigures the Rococo with its pale colour and bucolic imagery (Plate 38). Although Cortona was not personally responsible for the execution of all of the seven ceilings in the Pitti Palace (each dedicated to a planet on the old Ptolemaic system) with which he continued his work for the Medici, his pupils and assistants, under the guidance of Ciro Ferri, managed to perpetuate his style throughout. Of all Italian Baroque decorative schemes, this was the most important, and its immediate effect can be seen in Lebrun's ceilings at Versailles. From 1642 until his death, Cortona continued to receive important commissions, despite the death of Urban VIII in 1644 and the subsequent banishment of the Barberini,

and his latest style is seen in the Chiesa Nuova and Pamphili Palace frescoes in Rome, a style leading directly on to that of Luca Giordano.

Barberini taste was sufficiently catholic to allow their patronage of Andrea Sacchi, whose largest fresco, the *Divine Wisdom*, had the misfortune to be painted close enough to Cortona's fresco in the Barberini Palace to accentuate its dismal failure: Sacchi was not equipped or inclined to fill large spaces with multitudes of figures, and would have been horrified if Passeri had tried to see anything *other* than the individual parts of his pictures. In 1626, Sacchi was regarded as one of Rome's most promising painters, and apart from his work for Valguarnera (who financed his collection of Sacchi, Poussin and Reni with stolen jewels), was working extensively for the Barberini, for whom he painted *Hagar and Ishmael* (Plate 34). Sacchi appears to have suffered from considerable personal uncertainty with regard to the direction he would take, and although his preferred painters up to the 1630s were the more 'Baroque'—Barocci, Cigoli, Lodovico Carracci and Titian—his shift to Raphael, Annibale and Domenichino after 1640 accords much better with his own pronouncedly classical interests. Incapable of the purism of Poussin—also active in Rome in these years—and not inclined towards the stylistic bravura of the Baroque, Sacchi is best remembered for his two careful 'psychological' pictures showing differing human reactions to miraculous events, the *Miracle of the Corporal* and the *Vision of St Romuald*. It was, however, through Sacchi that the classical tradition of Annibale was transmitted to his pupil Carlo Maratti, who subdued one of the features of Sacchi's art which is at its most pleasing in the *Hagar*, his often rich handling of paint and colour in the Venetian manner.

The Barberini had maintained close ties with France, and from their exile in Paris

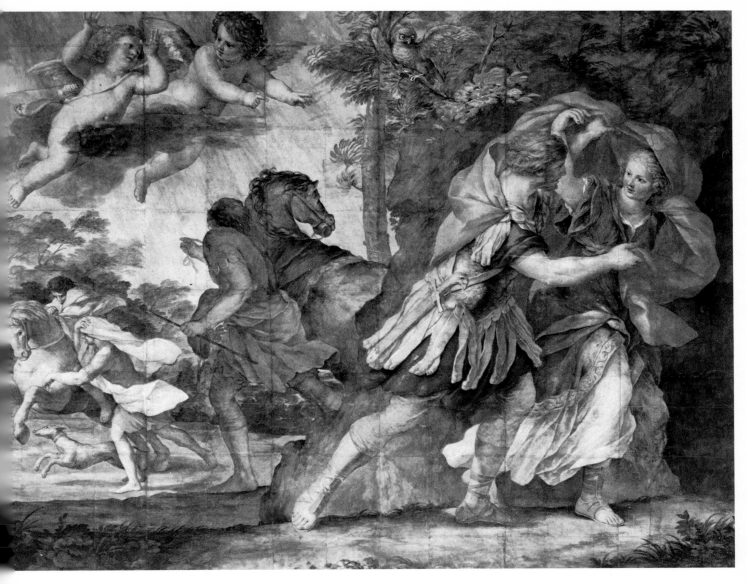

33. Giovanni Francesco Romanelli (1610?–62): *Dido and Aeneas in a Storm*. Gouache on paper laid on linen, 276.9 × 350.5 cm. (109 × 138 in.) Los Angeles, Norton Simon Foundation

after Urban VIII's death, they were instrumental in bringing Francesco Romanelli to the French capital in 1646 and again in 1655. During his second visit, he worked for Louis XIV on the decoration of Anne of Austria's Louvre apartments. Romanelli had been a pupil of Domenichino and came into contact with Cortona when the latter was at work on the Barberini Ceiling; he had recently been appointed to control the Barberini tapestry manufactory. The six large cartoons painted by Romanelli for a series of tapestries showing the Story of Dido (Plate 33) may have been commissioned by Louis XIV, and show the stylistic similarities and disparities between Romanelli and Cortona. The precision is typical of Domenichino, and Romanelli has tempered Cortona's grandiose gestures and drapery to achieve a compromise which would have delighted the French, and which later distinguished their version of the Baroque grand manner.

47

During the 1620s, when Cortona was evolving his Roman style in opposition to the realism of Caravaggio and the classicism of the Bolognese, many provincial painters were coming to maturity: the most important of these was Francesco Barbieri, called il Guercino on account of his unfortunate squint. Guercino inherited a painterly tradition from his native area around Cento, and coupled this with a strong chiaroscuro derived more from Venetian art than from any

early knowledge of Caravaggio. The flickering illumination of his first and most dramatic period (Plate 36) is utterly different from Caravaggio's strong, directional light. *Erminia Finding the Wounded Tancred* takes its subject from one of the Baroque's favourite texts, Tasso's *Jerusalem Liberated*. Guercino was largely self-taught, and his vigorous use of creamy paint in a colour-scheme dominated by dark grey, plum, blood-red and ochre in this picture make it one of the most dramatically

34. Andrea Sacchi (1599–1661): *Hagar and Ishmael in the Wilderness*. Early 1630s. Canvas, 96 × 92 cm. (37¾ × 36¼ in.) Cardiff, National Gallery of Wales

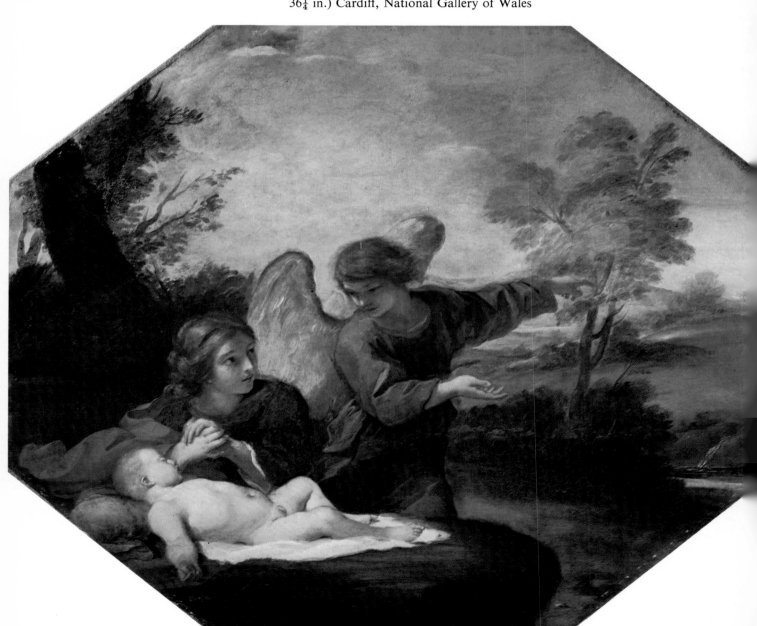

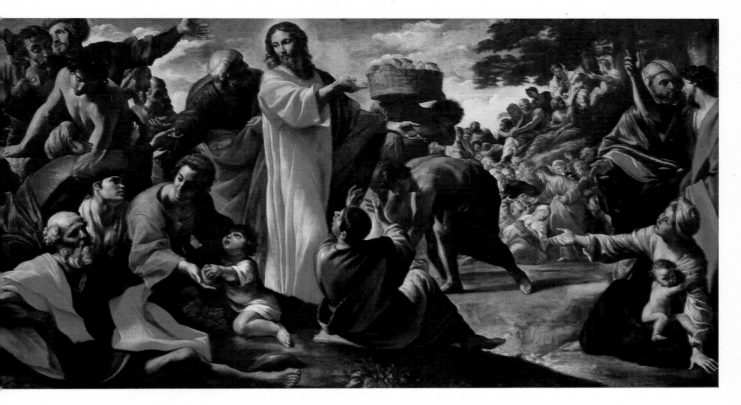

35. Giovanni Lanfranco (1582–1647): *The Miracle of the Loaves and Fishes.* 1625. Canvas, 229 × 426 cm. (89½ × 167¾ in.) Dublin, National Gallery of Ireland

effective renderings of the theme. After his trip to Rome in 1621 at the invitation of Cardinal Alessandro Ludovisi, when he painted the vast *Martyrdom of St Petronilla* (Rome, Capitoline Museum) and the *Aurora* in the Casino Ludovisi in a similar style, Guercino clearly began to feel that his success would be greater if he adopted something more akin to the Bolognese classical manner. To achieve this, after his return to Cento in 1623, he lightened his colour and applied a more even lighting, together with less movement and greater detail. Domenichino was in his mind when he painted the *Cumaean Sybil* (Plate 42), the type of picture avidly collected by the English *milordi* doing the Grand Tour, on which much of the strength of the eighteenth-century portraiture of Reynolds and his contemporaries was based. Guercino's change of mind, if not of heart, which was often attacked, even by his biographer Scanelli, as a decline from the natural spontaneity of his early

period, did not prevent the production of masterpieces such as his *Madonna and Child with St Bruno* (Plate 37). Among the paintings taken from Italy by the French in 1796, it typifies the sculptural forms and monumentality which he achieved in his later works. With an international reputation which brought him invitations to the courts of France and England (both of which he refused), he moved to Bologna on Reni's death in 1642 to take over his position.

Of other painters active in a less official style in central and northern Italy in the first half of the century, Bernardo Strozzi was among the most talented and, as a result of his move from his native Genoa to Venice in 1630, influential. Apart from Castiglione (Plate 62), Strozzi was the leading Genoese painter to profit from his experience of Rubens and Van Dyck, who had been in Genoa in 1606 and 1621 respectively. From Van Dyck, Strozzi evolved his nervous elegance, though

49

this had already been apparent to some extent in his borrowings from Mannerism, as in the spiky, brightly-coloured *St Catherine* (Hartford, Conn., Wadsworth Atheneum). Brilliant colour also characterizes his many allegories, notably that of *Vanity* (Plate 43). Allegorical representations of melancholy, fortune, wisdom, and many other abstract concepts are common in the Renaissance, proliferate in the Mannerist period, and are often simplified in the Baroque into such ostensibly *genre* scenes as this one of an aged hag who continues to adorn herself as in her vanished youth. The theme of the transience of all things save the soul recurs throughout the *Spiritual Exercises*, and is here given particular

36. Francesco Barbieri, called il Guercino (1591–1666): *Erminia Finding the Wounded Tancred*. 1618–19. Canvas, 145 × 187 cm. (57 × 97¼ in.) Rome, Galleria Doria Pamphili

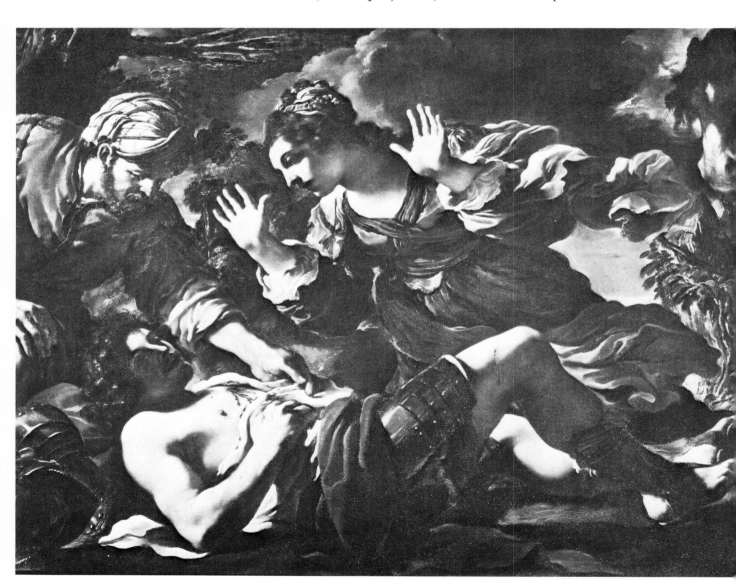

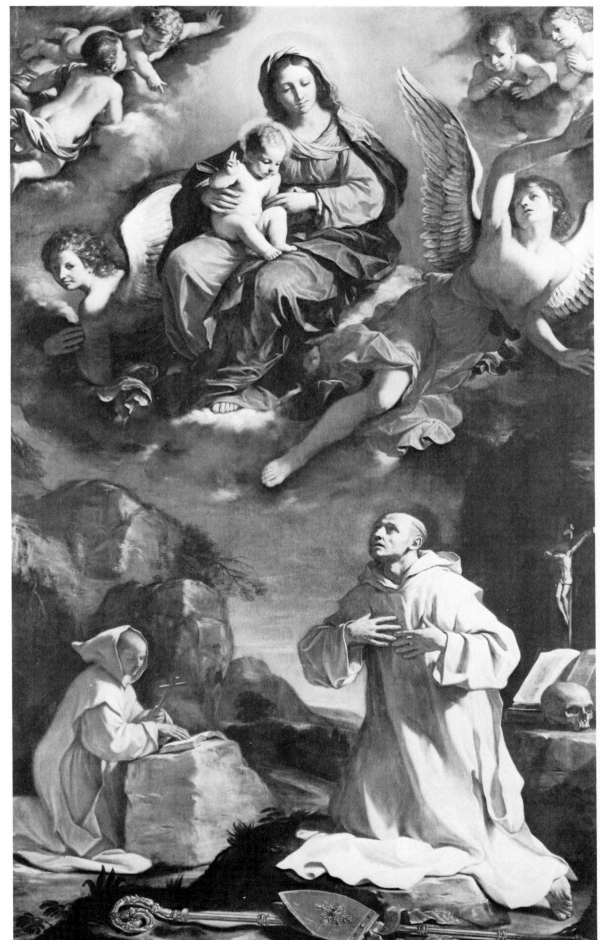

37. Francesco
Barbieri, called
il Guercino
(1591–1666):
*Madonna and Child
with St Bruno*.
Mid-1640s. Canvas,
392 × 233 cm.
(115 × 91¾ in.)
Bologna,
Pinacoteca
Nazionale

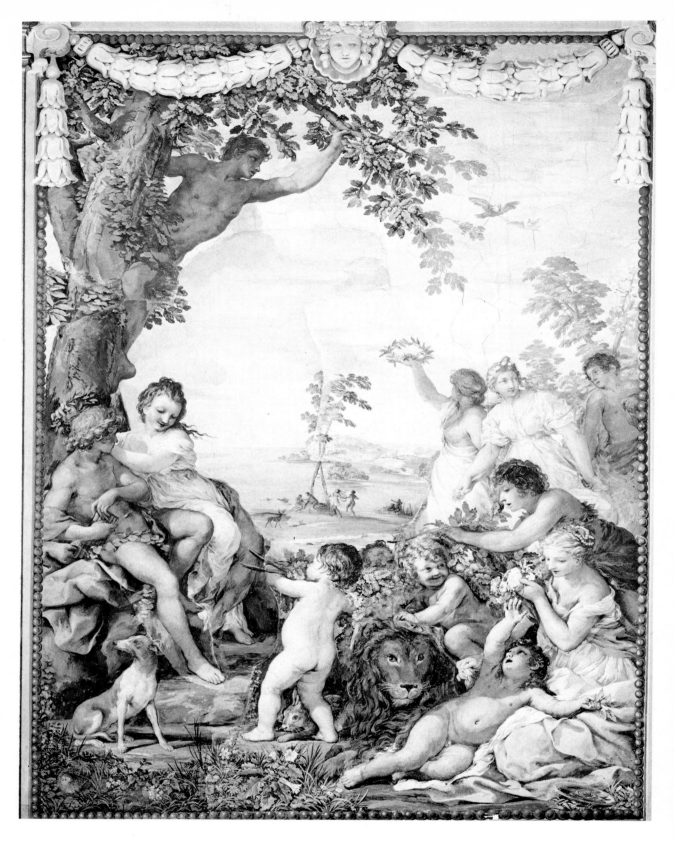

38 and 39(*detail*). Pietro da Cortona (1596–1669): *The Age of Gold*. 1637. Fresco. Florence, Pitti Pal., Sala della Stufa

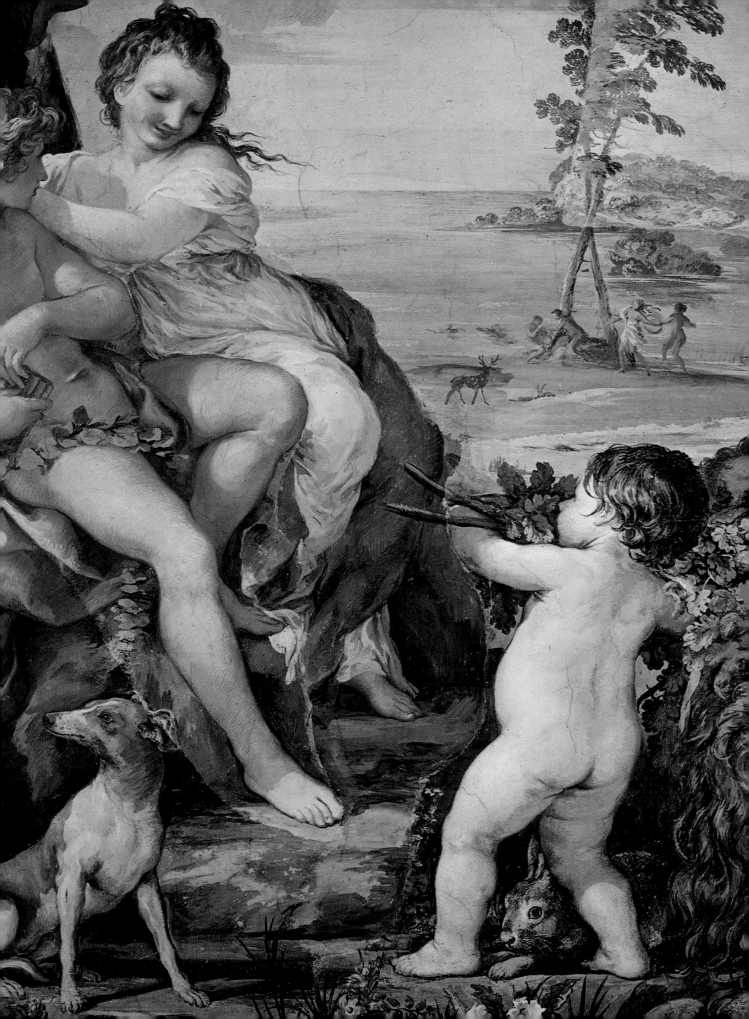

force by Strozzi's characteristic, lively technique and female types which recall Flemish realism. Strozzi's love of lavish fabrics and luxurious detail may partly derive from Orazio Gentileschi's Genoese sojourn, and this, coupled with influences rapidly assimilated after his arrival in Venice, resulted in one of the masterpieces of 'foreign' art in Venice, Strozzi's *St Sebastian tended by Irene* (Venice, S. Benedetto). Strozzi's art, together with that of the Florentine, Mazzoni, whom he profoundly influenced, and that of Francesco Maffei, constitutes Venice's most interesting seventeenth-century painting.

The arch-defender of Baroque non-conformism was, however, Salvator Rosa, made famous more as a proto-Romantic than as an innovatory landscape painter by Lady Morgan's enthusiastic study published in 1824. Neapolitan by birth but bohemian by in-

40. Salvator Rosa (1615–73): *Landscape with Apollo and the Sybil*. Mid-1650s. Canvas, 175.3 × 261 cm. (69 × 102¾ in.) London, Wallace Collection

clination, Rosa was initially strongly influenced by the Neapolitan followers of Caravaggio, Giovanni Battista Caracciolo (died 1637), Massimo Stanzione (1585-1656) and the Spaniard, Jusepe Ribera (1591-1652), whose sombre Caravaggism corresponded with the taste of the viceroys of a Naples under Spanish rule since the early sixteenth century. Rosa's paintings can be confusingly varied in quality, and indeed his attention veered between satirical verse-writing and painting with an overlap occasionally detrimental to the latter. His initial study with Ribera and Aniello Falcone (inventor of 'the battle-scene without a hero') was followed, after his arrival in Rome in 1635, by an increased awareness of classicism and a rapid evolution of his personal style of landscape and figure painting (Plate 40). Supposedly to escape the repercussions of his satirical poems, Rosa went to

41. Domenico Zampieri, called Domenichino (1581–1641): *Landscape with St George Killing the Dragon*. About 1610—11. Panel, 52.9 × 61.9 cm. (20¾ × 24⅜ in.) London, National Gallery

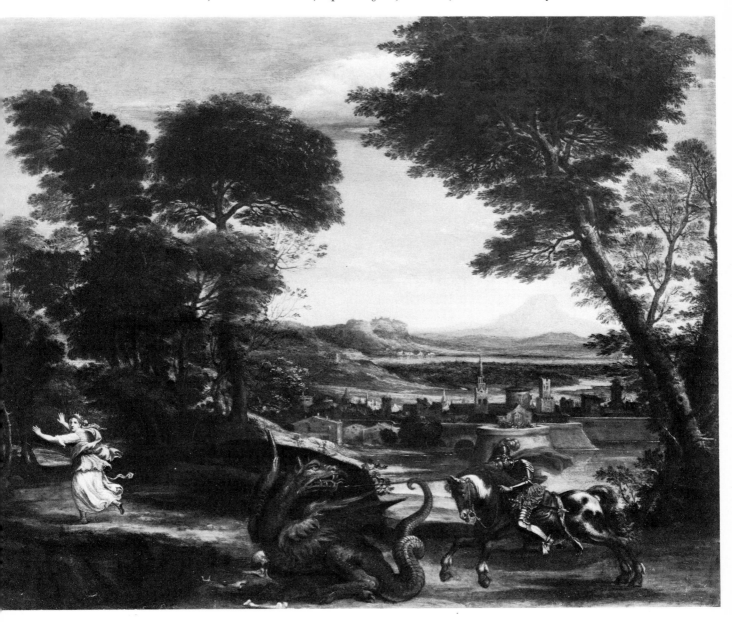

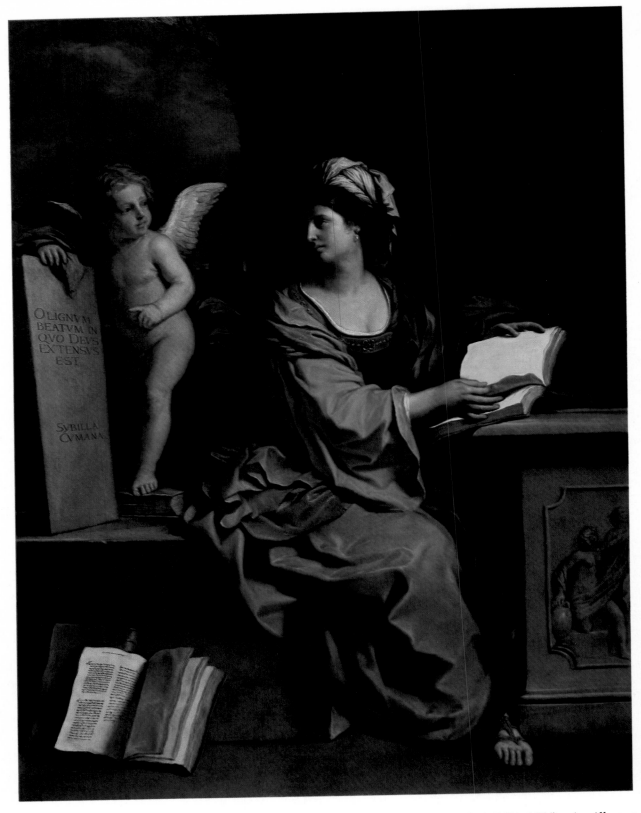

42. Francesco Barbieri called il Guercino (1591–1666):
The Cumaean Sybil with a Putto. 1651. Canvas, 222 ×
168.5 cm. (87½ × 66⅜ in.) London, Denis Mahon Coll.

43(*right*). Bernardo Strozzi (1581–1644): *An Allegory of
Vanity*. About 1630. Canvas 132 × 108 cm. (52 × 42½ in.)
Bologna Private Collection

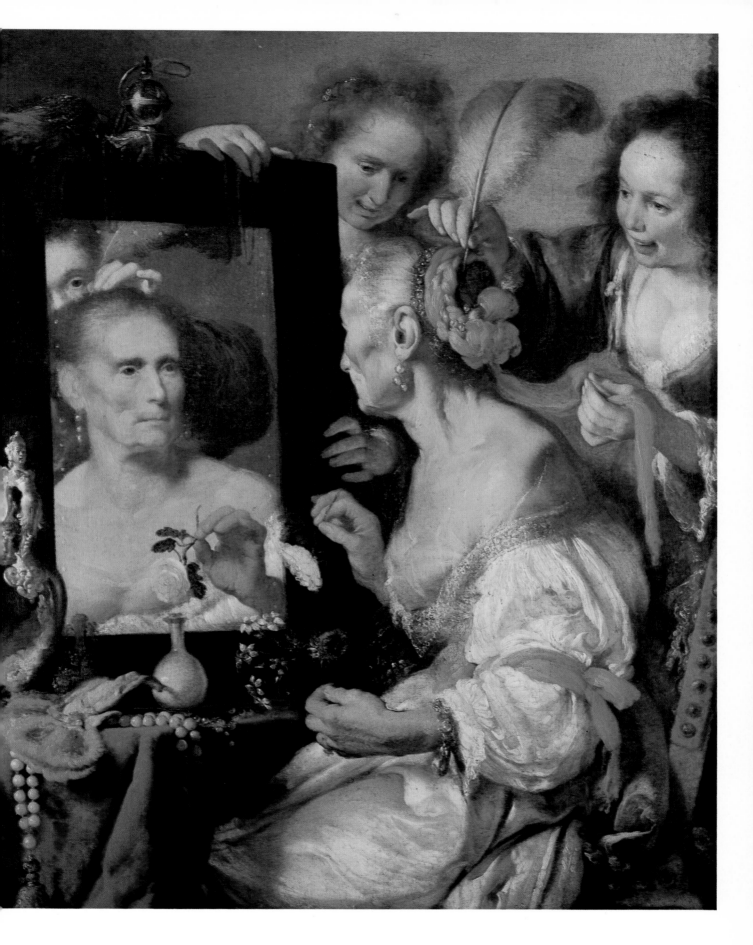

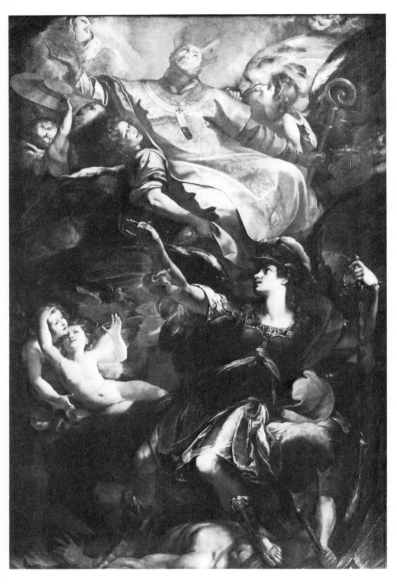

44. Giulio Cesare Procaccini (1574–1625): *St Charles Borromeo in Glory with the Archangel Michael.* About 1618. Canvas, 384 × 250 cm. (151¼ × 98½ in.) Dublin, National Gallery of Ireland

Florence in 1641, and spent the following eight years in Tuscany, where not only did the Grand Duke find his magnificent seaports and battle-scenes to his taste, but also Rosa was surrounded by congenial painter-poets such as Lorenzo Lippi, who shared his taste for witchcraft, the bizarre and the unconventional. His return to Rome saw the production of his immensely influential etchings of brigands and pirates in 1656 and a revived interest in more classical landscapes, such as those of the Frenchman, Gaspard Dughet, whom Rosa was certainly attempting to rival in his magnificent *Landscape with Apollo and the Cumaean Sybil* (Plate 40). Taken from Ovid's *Metamorphoses* (another much-used source for Baroque pictorial imagery in both painting and sculpture), its jagged rocks and feathery, somehow sinister trees typify Rosa's usual style. The distant glow on the horizon and the wonderfully modulated tonal range, highlighted by the red and yellow notes of the costumes, combine with the grandeur of the landscape to mark this as the climax of 'sublime' landscape painting.

Rosa's vision of himself was undeniably romantic (Plate 46), especially when seen beside one of the century's masterpieces of official portraiture, Reni's *Cardinal Bernardino Spada* (Plate 47), poised with thoroughly artificial spontaneity in his study. In contrast to the sumptuous but deliberately limited range of reds and pinks dominating Reni's likeness of the cardinal (who was papal legate in Bologna from 1627 to 1631), Rosa's palette is confined to severe blacks, browns and greys in keeping with the painted inscription, which means 'Be silent, unless your speech improves on silence.'

The fierce individualism both in art and life-style which Rosa personifies—and which belongs to the tradition initiated somewhat dramatically by Caravaggio himself—is not apparent in the school of painters who grew

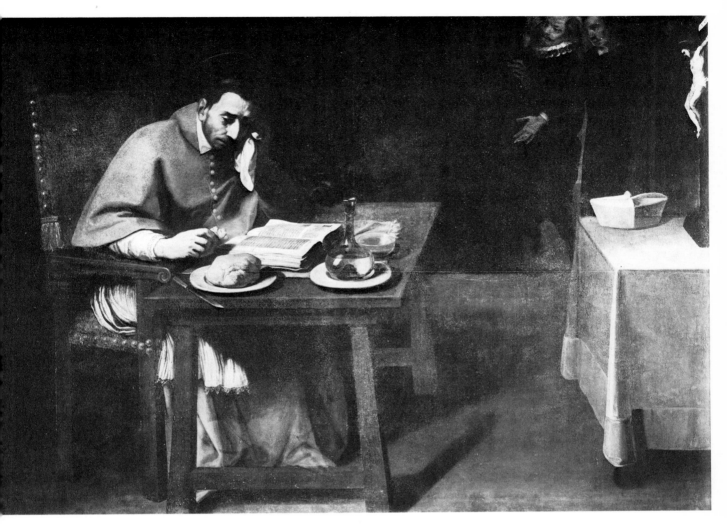

45. Daniele Crespi (About 1598–1630): *The Fast of St Charles Borromeo*. About 1628. Canvas, 162 × 188 cm. (63¾ × 74 in.) Milan, Chiesa della Passione

up in the wake of Cardinal (later Saint) Charles Borromeo's reforms in Milan. Borromeo in his *Instructiones*, written after 1572, insisted on the closest collaboration between artists and priests, and the results are apparent in Lombard painting and sculpture throughout the last years of the sixteenth century and up to the death in 1631 of his cousin, Federico Borromeo, who had succeeded him as Archbishop of Milan. In the preceding year, plague had swept through northern Italy, as it had in 1576 during Charles Borromeo's lifetime, when he had shown the courage and organizing ability which explain the unique position he occupies in Counter-Reformation iconography (Plates 44 and 45). Many painters of this period, such as Morazzone, il Cerano and G. C. Procaccini, belong partly to a late Mannerist phase peculiar to Milan, and never espouse the virile 'return to nature' of Anni-

59

bale or Caravaggio. Artistic production was unprecedentedly vast, with a variety of concessions to a semi-Baroque style. Procaccini's *St Charles Borromeo in Glory with the Archangel Michael* (Plate 44), so much admired by Carlo Maratti that he offered to buy it in Rome, has a composition based on wildly swerving diagonals, which suggests a parallel with Lanfranco or even with Rubens, since, according to Soprani, Procaccini visited Genoa

in 1618, the year in which he painted this picture. Its image of St Charles conforms to the more usual type of Italian Baroque heaven-borne vision, while Daniele Crespi's picture of the saint fasting (Plate 45) has been compared to the objectivity of Zurbarán in Spain. Crespi, who died in the 1630 plague, has been called 'a spirit as devoid of passion as it was endowed with the capacity for analysis', and this painting subtly performs several roles:

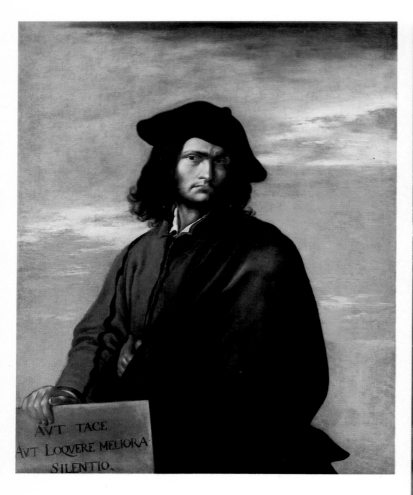

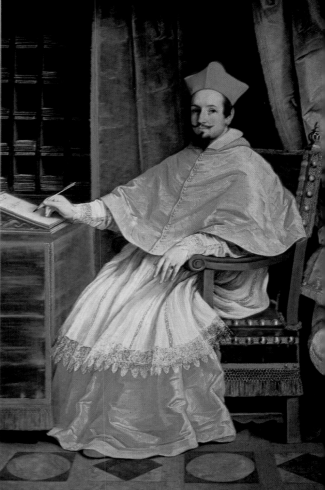

46. Salvator Rosa (1615–73): *Self-Portrait*. About 1641. Canvas, 115 × 92 cm. (45¼ × 36¼ in.) London, National Gallery

47. Guido Reni (1575–1642): *Cardinal Bernardino Spada*. 1631. Canvas, 222 × 147 cm. (87½ × 57 in.) Rome, Galleria Spada

60

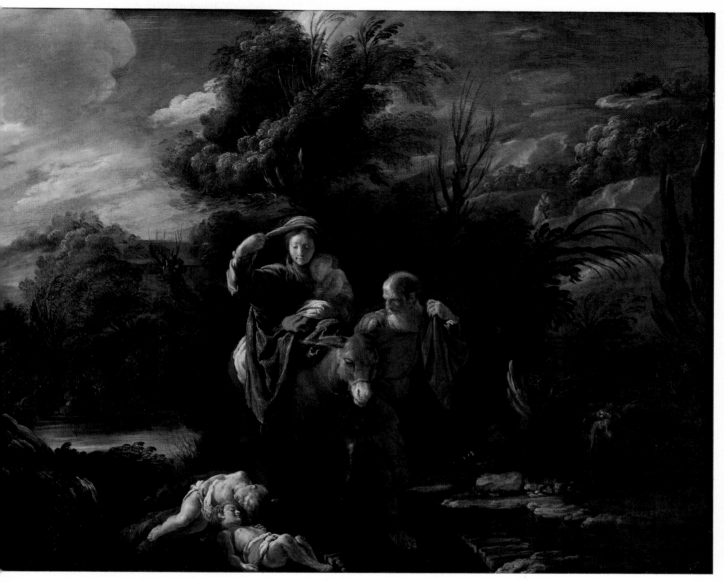

48. Domenico Feti (1589–1623): *The Flight into Egypt.* About 1621–3. Canvas, 63 × 82 cm. (24¾ × 32¼ in.) Vienna, Kunsthistorisches Museum

while permitting us to see the saint in con-templation, it makes us feel part of the wonderment of his contemporaries at his qualities, by the silent and unseen intrusion of two figures in the background. Such natural-ism is very different from Tanzio da Varallo's grim *St Roch Interceding on Behalf of the People of Camasco* (Plate 49), a proletarian *ex voto* by the painter credited with having introduced Caravaggism to Milan after his

Roman visit. Tanzio's was one of the more original talents in early *Seicento* Lombardy, and his pallid, starved saints set in Gothick landscapes coloured with bilious intensity pre-pare the way for the fascinating Francesco del Cairo. Del Cairo's own shady personality is reflected in the series of half-length swooning nocturnal heroines for which he is best known. Whether in the guise of *Salome* (Plate 50) in her private orgy of necrophiliac passion, or as

61

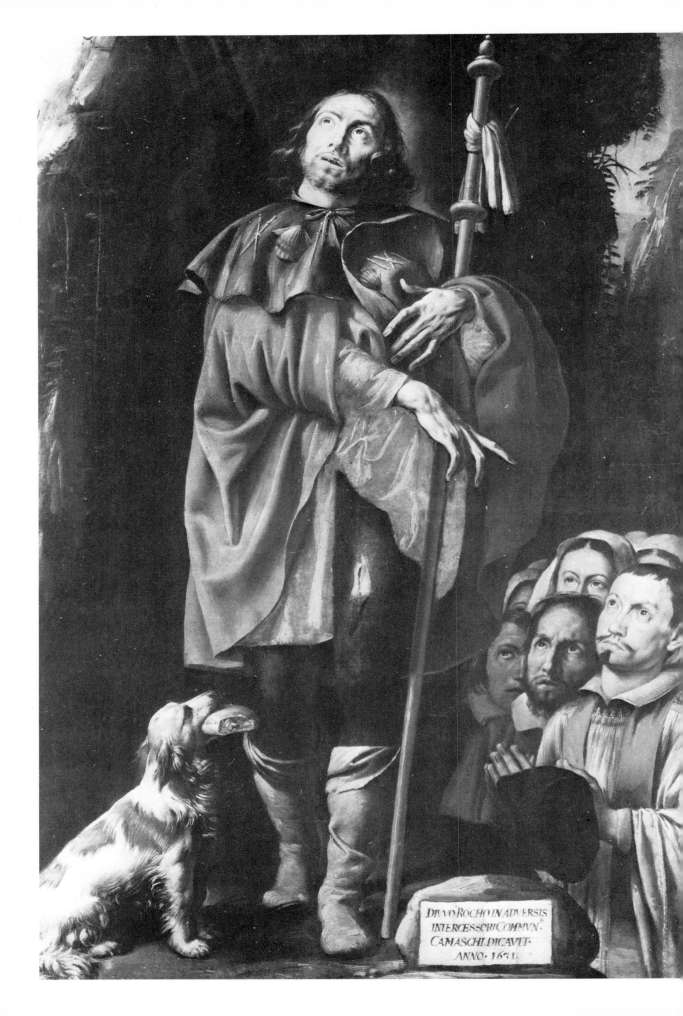

DIVVO ROCHO IN ADVERSIS
INTERCESSORI COMMVN.
CAMASCHI DICAVIT
ANNO · 1631 ·

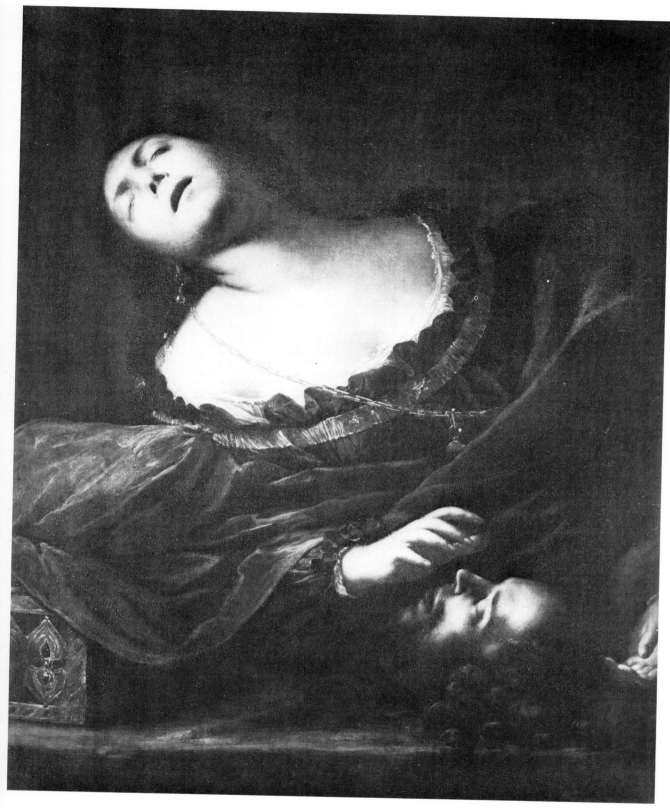

49(*left*). Tanzio da Varallo (About 1574–1635): *St Roch
Interceding on Behalf of the People of Camasco*. 1631.
Canvas, 190 × 125 cm. (75 × 49¼ in.) Varallo, Pinacoteca

50(*above*). Francesco del Cairo (1607–65): *Salome*.
Before 1635. Canvas, 102 × 82 cm. (40¼ × 32¼ in.) Turin,
Galleria Sabauda

51. Cesare Dandini (1596–1656): *Charity*. About 1635-40. Canvas 119.4 × 105.4 cm. (47 × 41½ in.) New York, Metropolitan Museum, Gift of Mr and Mrs Ralph Friedman

64

Lucretia (Madrid, Prado), they share the same unhealthy fascination as their contemporaries in Florence at the hands of Dolci, Pignoni and Ficherelli. Del Cairo's appointment to the post of Court Painter at Turin in 1648 removed the last talent of the century from Milan: properly speaking, Magnasco belongs to the Rococo in its earliest phases.

After what might be described as an all-too-healthy end to the sixteenth century in Florence with the often simplistic compositions of Jacopo da Empoli and the uncertain, semi-Baroque of much of Cigoli, the seventeenth century really got under way in the late teens and twenties with a host of minor talents, each of whom painted a handful of important pictures. Matteo Rosselli, who trained many of the leading painters who came to maturity in the mid-century, was himself generally pedestrian, and the first signs of a real awakening come with Jacopo Vignali, some of whose religious paintings achieve a remarkable degree of emotional intensity. Cristofano Allori's death in 1621 robbed Florence of one of her greatest talents of this period, but his pupil, Cesare Dandini (Plate 51), proved capable of striking images, as decadent in their way as del Cairo's. His mask-like faces of deathly pallor with vampirically crimson lips have a suspended, motionless quality which recalls Bronzino, although on the whole it was rather to earlier masters such as Andrea del Sarto that many Florentines of this period reverted for inspiration. Cesare Ripa, in his textbook of iconography, the *Iconologia* (published in 1611), described Charity in almost exactly the way Dandini shows her: the adherence of Baroque artists to such manuals was often very close.

Cesare Dandini and many lesser painters all prepared the way for the painter who was certainly the most famous Florentine artist of his day, Carlo Dolci. The exact antithesis of Baroque extravagance in his technique, Dolci's

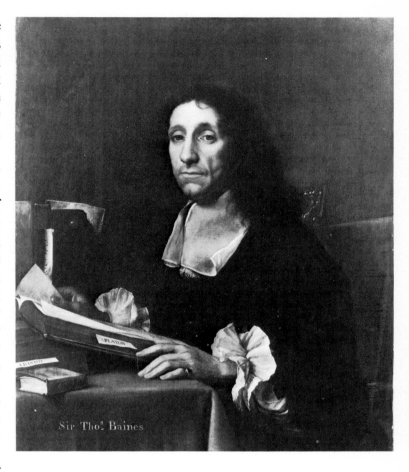

52. Carlo Dolci: *Portrait of Sir Thomas Baines*. 1665–70. Oil on canvas, 86.4 × 72.4 cm. (34 × 28½ in.) Cambridge, Fitzwilliam Museum

65

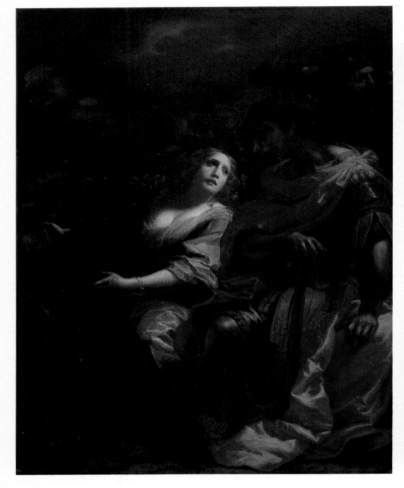

53. Simone Pignoni (1611–98): *David and Abigail.*
Canvas, 176.5 × 136.5 cm. (69½ × 53¾ in.) Florence,
Private Collection

54. Carlo Dolci (1616–86): *David with the Head of Goliath.* Completed, signed and dated 1680. Canvas,
131.5 × 104 cm. (51¾ × 41 in.) Private Collection

extreme piety and his later devotion to almost exclusively religious subject-matter have led to an undervaluing of his painting, which can be remarkable. His super-realist technique (for which he has been attacked repeatedly), coupled with his close dependence on the model (Plate 54), often has surprising impact. Together with its pair, the *Salome* also painted for the Rinuccini family in Florence, *David* was always regarded as one of the master-pieces of its period. Dolci's religiosity was only an extreme example of a fervour shared by many artists of the period, and the melancholy which emanates from many of his paintings for the Medici and other noble Florentine

families and for an international clientele (Plate 52) is perhaps the essence of the *Seicento* in Florence. Dolci's paranoid concern with detail made him a portraitist of distinction, and also led him to include still-life detail of great beauty in many of his works. The recent tendency to regard Cortona's advent in Florence as the salvation of Tuscan painting was not shared by the perceptive nineteenth-century historian, Giovanni Rosini, who placed Cortona at the beginning of its final decline. Whether or not this seems justified, the work of other Florentines, such as Simone Pignoni, remains as proof of the strength of native Florentine talent in this period. Pignoni, the

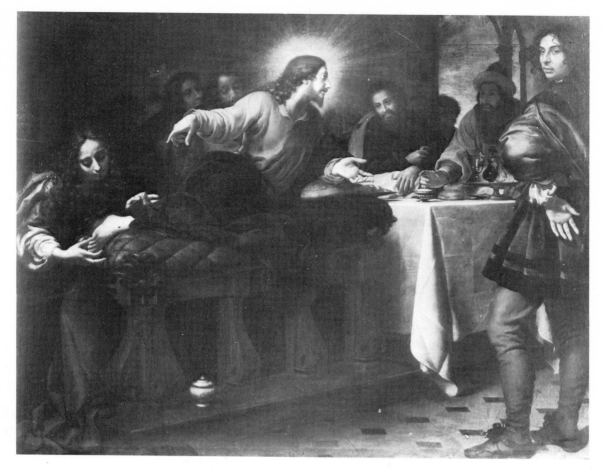

55. Carlo Dolci (1616–86): *Christ in the House of the Pharisee*. Signed and dated 1649. Canvas, 175.3 × 191.1 cm. (69 × 85¼ in.) Corsham Court, Methuen Collection.

56. Bartolommeo del Bimbo, called il Bimbi (1648–1729): *Still-Life with Cherries*. 1699. Canvas, 116 × 155 cm. (45⅝ × 61 in.) Florence, Galleria Uffizi

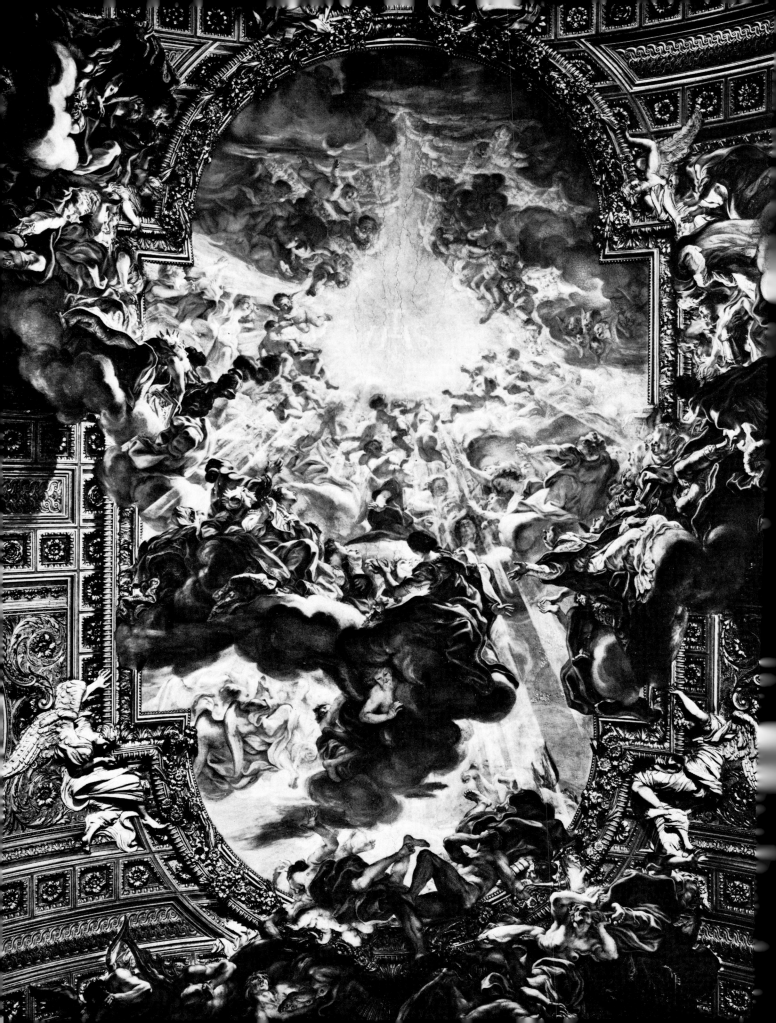

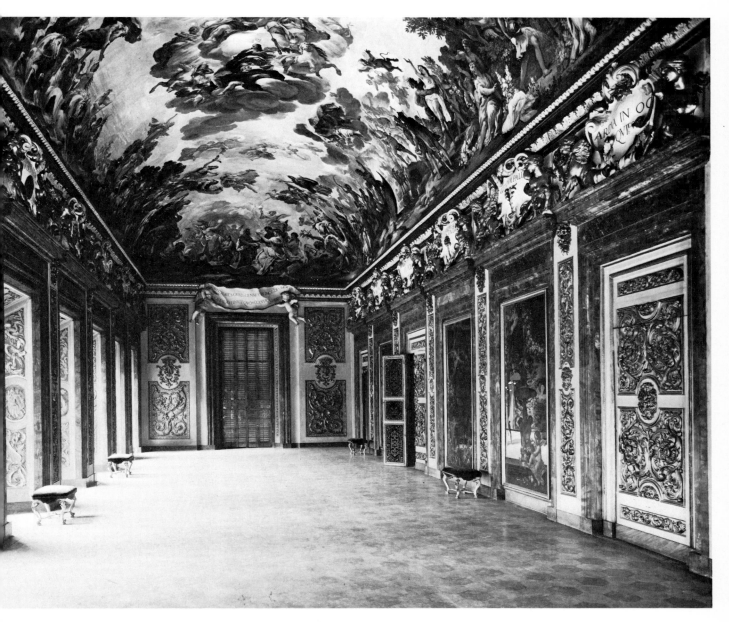

57(*left*). Giovanni Battista Gaulli, called il Baciccio (1639–1709): *The Adoration of the Name of Jesus* (detail—central part of the great vault). 1672–85. Fresco. Rome, Chiesa del Gesù

58(*above*). Luca Giordano (1634–1705): *The Medici-Riccardi Gallery*. 1682–5. Fresco. Florence, Medici-Riccardi Palace

best pupil of Francesco Furini, the famous painter of the female nude, moved away from his early imitations of his master's style and, late in life, painted his masterpiece, *David and Abigail* (Plate 53)—a dazzling series of spark-ling, highlit colours of cosmetic artificiality, set against a dramatically dark background full of foreboding. In some ways, the later achieve-ments of more completely Baroque converts to Cortonism in Florence—Volterrano,

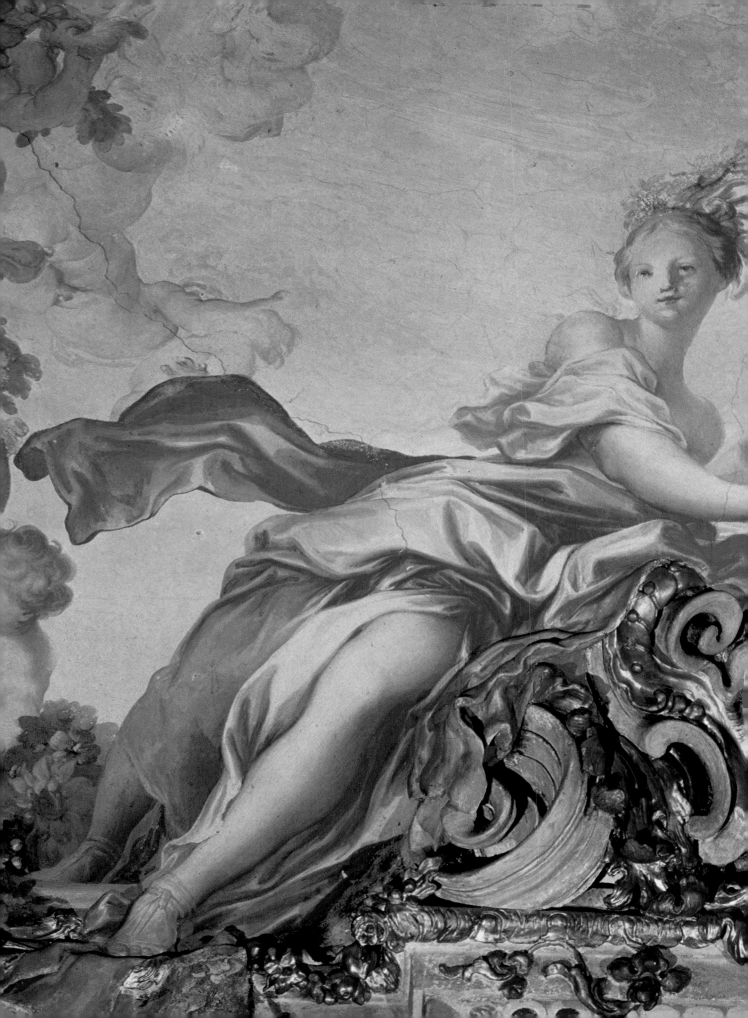

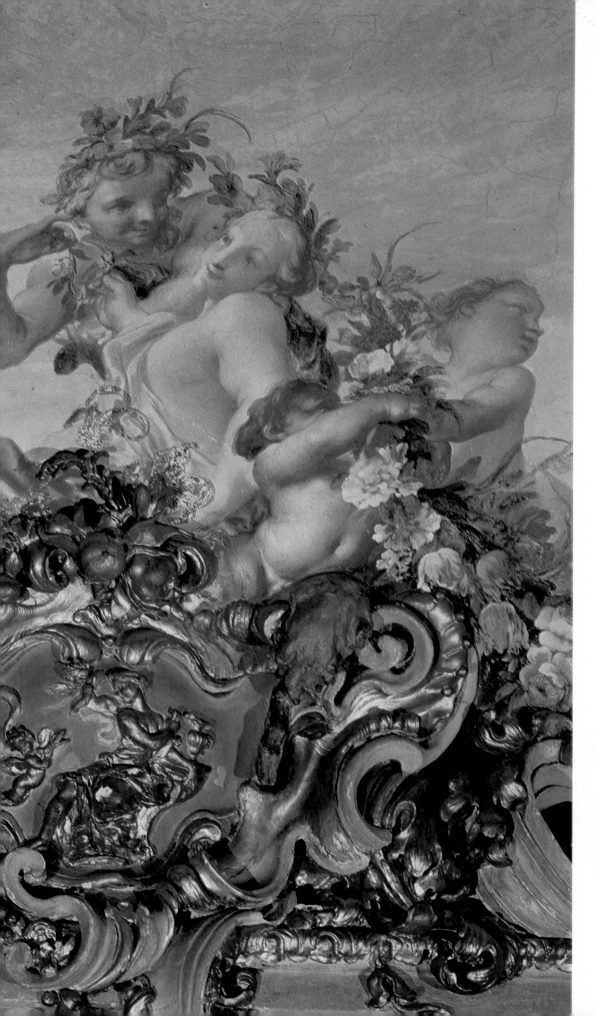

59.
Gregorio
de Ferrari
(1647–
1726):
*Cupid and
Psyche*.
1692.
Fresco.
Genoa,
Granello
Palace

71

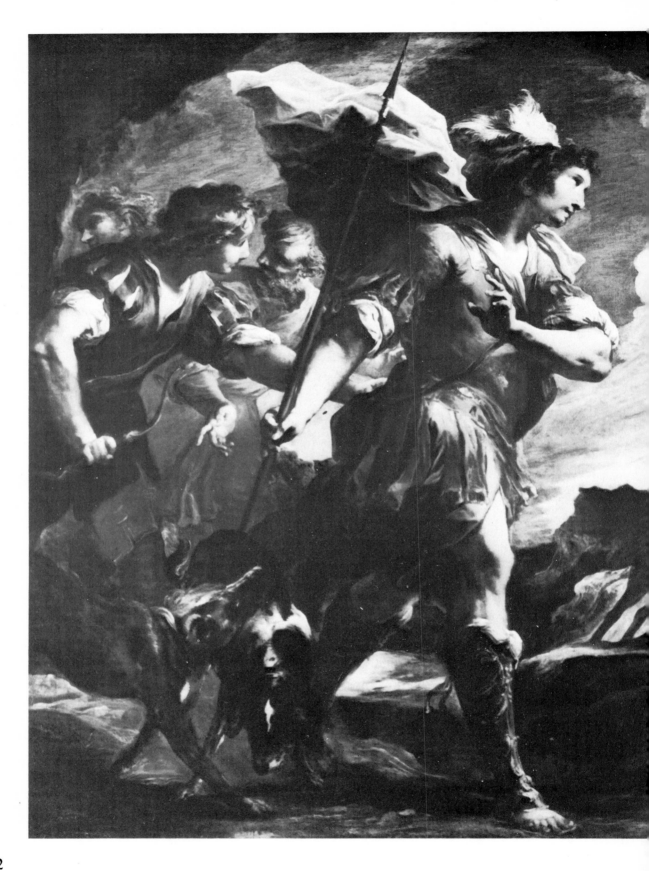

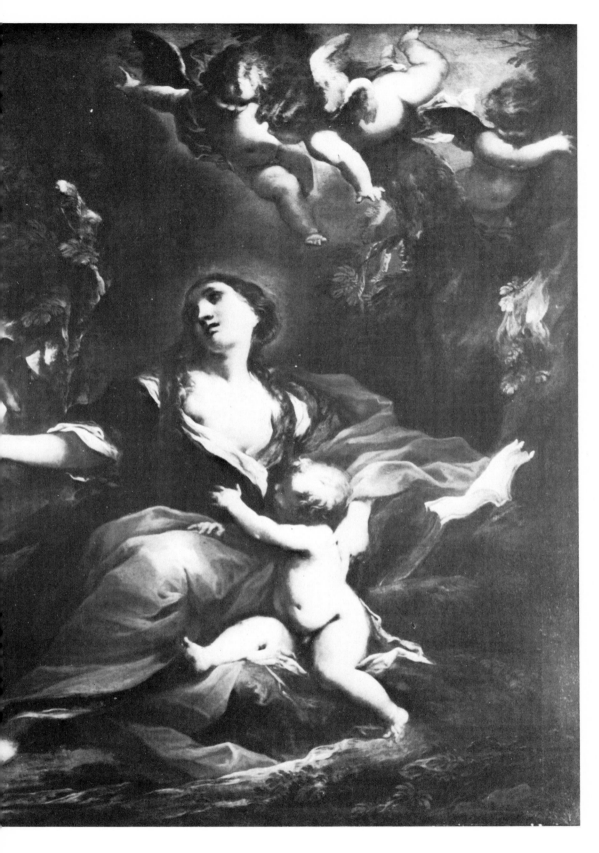

60. Valerio
Castello
(1624–59):
*The Legend
of St
Genevieve
of Brabant*.
About
1650.
Canvas,
256.5 ×
165.7 cm.
(101 ×
65¼ in.)
Norfolk,
Virginia,
Chrysler
Museum

73

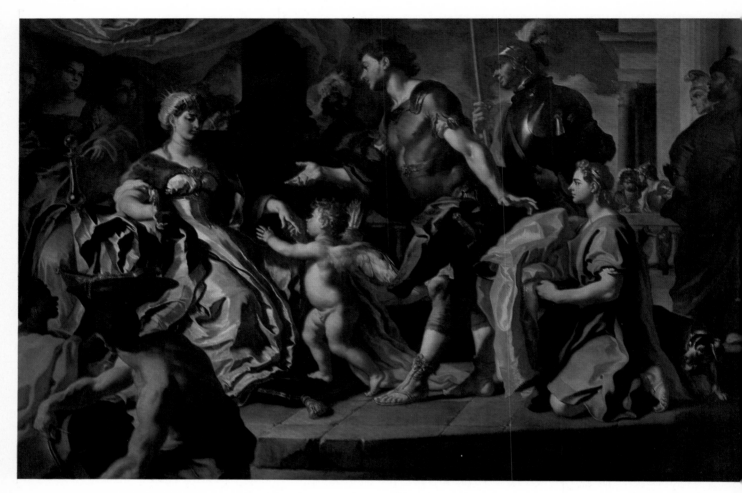

61. Francesco Solimena (1657–1747): *Dido and Aeneas*. About 1720. Canvas 107.5 × 309.5 cm. (42¼ × 122 in.)
London, National Gallery

Sagrestani, Bonechi, Gherardini and others—
rarely live up to this highly original image.

With the exception of the painting of Carlo
Maratta, the greatest talent during the re-
mainder of the century was devoted to decor-
ative painting on a large scale (Plates 57, 58,
63, 67 and 68), which, generally speaking,
only consolidated the achievements of the
first sixty years, and began to transform the
High Baroque style into the early Rococo
(Plate 64). Two immense vault frescoes in
Roman churches (Plates 57 and 68) carried
different aspects of the illusionist tradition to

their ultimate conclusions, while the most
energetic late Baroque decorator, Luca Gior-
dano, carried the style to Florence (Plates 58
and 63) and Venice, and finally to Spain,
where he remained for ten years.

Giovanni Battista Gaulli, il Baciccio (a
Genoese abbreviation of his Christian names),
left Genoa in the 1650s and entered Bernini's
Roman studio. The combination of Bernini's
sculptural style with Correggio, whom he
studied on his visit to Parma in 1669, resulted
in the most successful example of all Baroque
illusionism, the fresco on the Gesù vault, (Plate

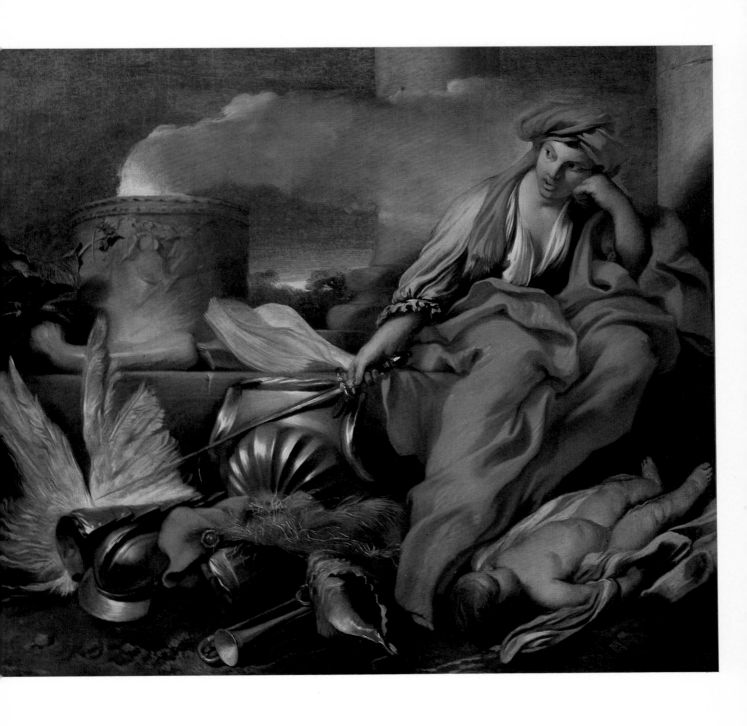

62. Giovanni Benedetto Castiglione (About 1600–65): *Medea Casting a Spell*. About 1655. Canvas, 71.1 × 81.2 cm. (28 × 32 in.) Hartford, Connecticut, Wadsworth Atheneum, Ella Gallup Sumner and Mary Catlin Sumner Collection

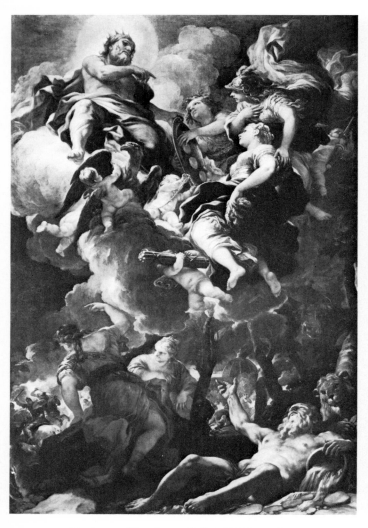

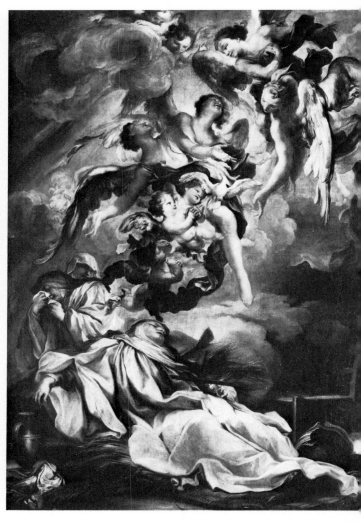

63. Luca Giordano (1634–1705): *Allegory of the Peace between Florence and Fiesole.* About 1682. Canvas, 340 × 222 cm. (133¾ × 87⅛ in.) Florence, Pitti Palace

64. Gregorio de Ferrari (1647–1726): *The Death of St Scolastica.* Genoa S. Stefano

57) which overlaps the architecture and surrounding sculpture to convince the spectator beneath that the heavens are indeed opening around the central monogram in its blaze of light. Although the text from the Epistle of St Paul, 'at the name of Jesus every knee shall bow', had inspired previous painters, it had never received such a triumphant pictorial setting, and ultimately this signified the triumph of both the Jesuits and the Church.

Andrea Pozzo's vault fresco in S. Ignazio in Rome (Plate 68) exemplified not the ceiling tradition inspired by Correggio, where the figures float free in the unrestricted space 'above' the 'opening' in the ceiling, but rather a north Italian tradition, where the architecture of the lower, real space is 'extended' upwards by the painting and in it move figures which thus seem closer to the spectator.

Two painters exemplify the end of the

76

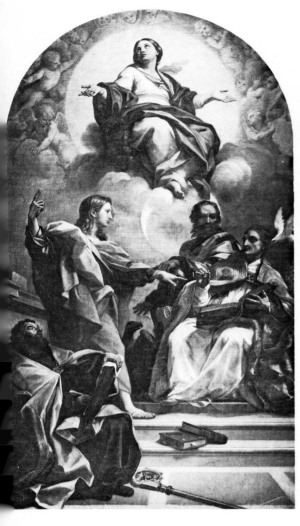

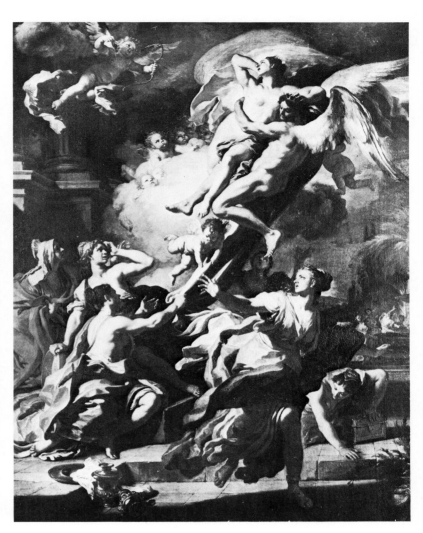

65. Carlo Maratta (1625–1713): *The Immaculate Conception with Saints.* 1685–6. Canvas. Rome, Sta Maria del Popolo

66. Francesco Solimena (1657—1747): *The Rape of Orythia.* 1700. Canvas, 114 × 86.5 cm. (44⅞ × 34 in.) Vienna, Kunsthistorisches Museum

Baroque tradition in Italy at its most grandiose: Carlo Maratta and Francesco Solimena, both of whom lived well into the eighteenth century, the one dominating Roman art, the other Neapolitan. In his *Rape of Oreithyia* and *Dido and Aeneas* (Plates 66 and 61), Solimena uses the dramatic action of the Baroque (so lightly applied by the short-lived Genoese, Valerio Castello, to his *St Genevieve*—Plate 60) in a ponderous, deliberately rhetorical way similar to that of many of Maratta's splendid altarpieces (Plate 65). Sacchi's major pupil, Maratta came to Rome from Camerano in 1636, and, from about 1680 until his death, filled the role previously held by Bernini as Rome's virtual artistic dictator and one of the most famous European artists of his day. If the style of *The Immaculate Conception* seems frigid, it is perhaps partly due to the fact that by the time it was painted in the later 1680s,

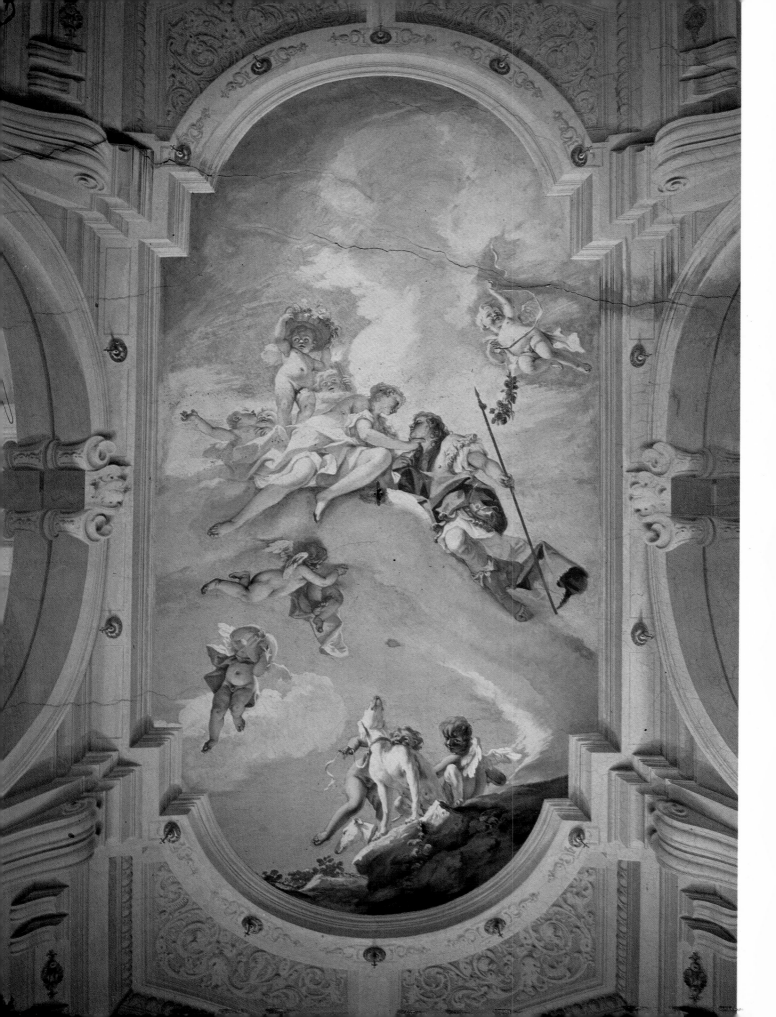

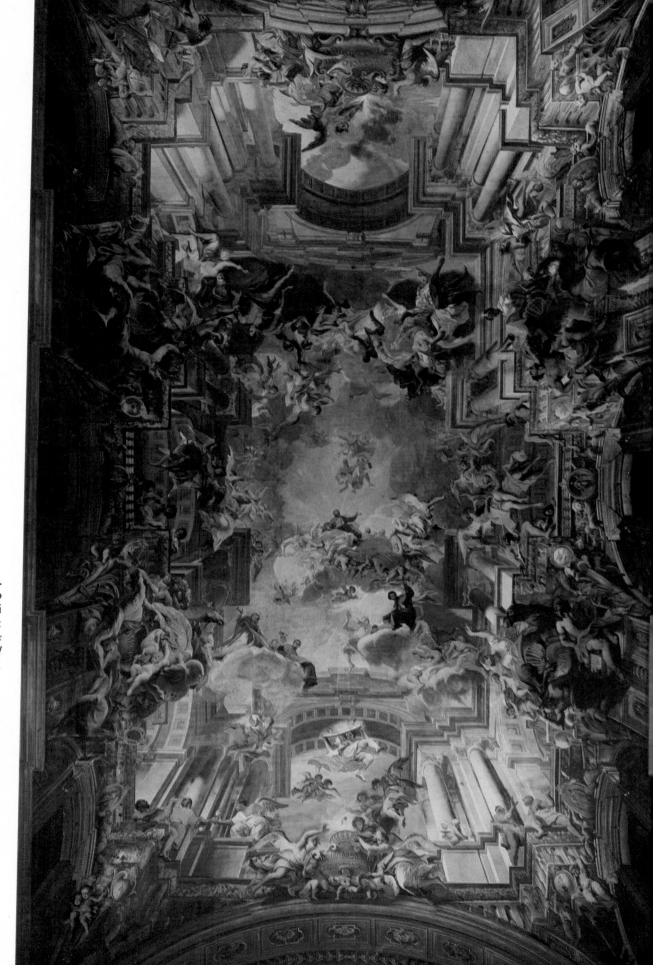

67(*left*).
Sebastiano
Ricci
(1659–1734):
*Venus Bids
Farewell
to Adonis*.
About 1707–8.
Fresco.
Florence,
Pitti Palace

68(*right*).
Andrea Pozzo
(1642–1709):
*The Apotheosis
of S. Ignazio*.
1691–4.
Fresco. Rome,
S. Ignazio

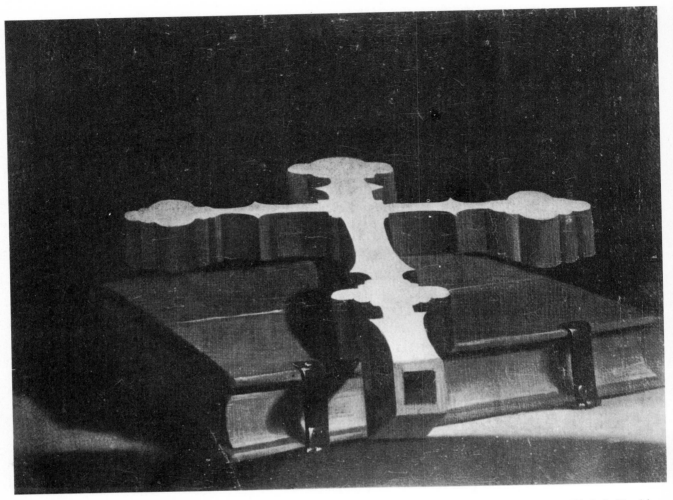

69. Carlo Maratta (1625–1713): *A Cross and a Book*. 1646. Canvas 34.3 × 44.5 cm. (13½ × 17½ in.) Dorking, Trustee of the J. H. C. Evelyn Will Trust

the immense wave of Catholic enthusiasm which had carried with it some of the finest achievements of the Baroque, had passed. It is appropriate that Maratta should have painted, forty years previously, a tiny canvas for the English diarist whose picture of Baroque Italy is still so stimulating, John Evelyn (Plate 69). On the back was inscribed: '*A Cross on a Book turning every way as the spectator turns | Painted by Carlo Maratti (the Pope's painter) at Rome* 1646 *for John Evelyn*.' This microcosm of the Baroque combines Caravaggio's stark realism with something of the illusionism so fundamental to the great decorative schemes, and the unquestioning piety of the Counter-Reformation: its very reticence makes it a suitable culmination to a century of splendour.

80